Distressingly perceptive, beautifully absurd, seriously thought-provoking. Lovely work, somehow all so familiar and strange. Bloody brilliant!!! The most intriguing art gallery I have ever seen! The extraordinariness of ordinariness — be seduced and enthralled. Opens one's eyes to the beauty and squalor of everyday life. You're never going to run out of material are you? Love the smut. Only in Britain... It's worrying. Commendable contemporary cultural consensus caravan. Fantastically accurate depiction of contemporary Britain. Fantastic — never heard so many people laughing in a gallery space. Brilliant, funny, poignant — captures the humour of Britain perfectly.

Welcome to Britain

Lots of cool weird stuff. Truth is stranger than fiction. I want to win meat in a raffle. Still the best show on the road. Can we really be like this? There should be a caravan art gallery in every town and city in the UK. Completely inspired — makes me proud to be British. Great to see some joy in the middle of the High Street. Pure dead brilliant!!!! Get some pictures of the deep-fried creme eggs in Glasgow. We are crackers aren't we really? Certainly worth driving 60 miles to see. Extremely extraordinary. Makes us want to go back to the Museum of Gas in Fakenham. Totally caravanic. Refreshing like salad.

Dedicated to the staff at the
Department of Hepatology,
Southampton General
Hospital, and Addenbrooke's
Hospital Transplant Unit,
without whom this book
would not have been possible.

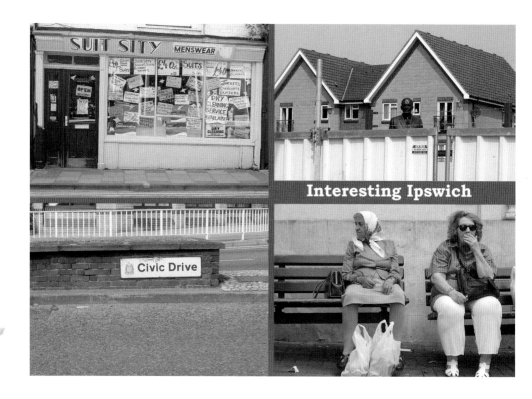

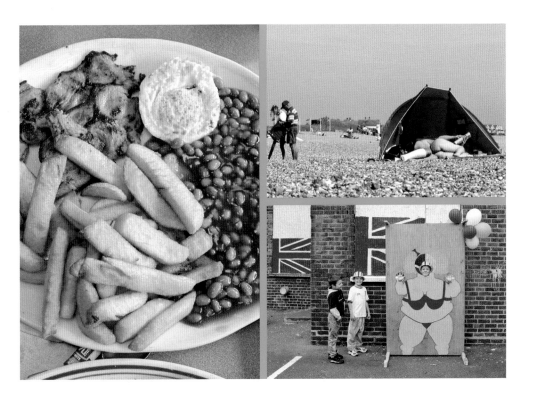

Welcome to Britain

A Celebration of Real Life

Jan Williams and Chris Teasdale

The Caravan Gallery

headline

Acknowledgements

We would like to thank everyone who has helped The Caravan Gallery on its way, whether wielding paintbrushes, providing parking space, giving publicity or simply taking part in 'The Caravan Gallery Experience' as a visitor.

Thanks to all the galleries and venues, festival and event organisers who have invited us to pitch up – or, at least, allowed us to gatecrash – and to all who have provided support, especially the former Southern Arts, Arts Council South East and the Scottish Arts Council. Particular thanks to all our friends and colleagues at Art Space Portsmouth and Aspex Gallery, Portsmouth, and to random Caravan Gallery fans in various parts of the world. Thanks also to The Lovely Ian at YCUK for peddling our postcards so splendidly.

Thanks to all at Headline and to Dan and Emma at Perfect Books for having faith in us and being so great to work with.

A massive thank you to assorted friends and family, especially Our Pat, Our Henry, Our Paul and Our Rachel Williams and to Maryrose and Henry Merritt, all cremeux and delicioso, for copious amounts of love and support.

Finally, thanks to Great Britain for being so photogenic.

Copyright © Jan Williams and Chris Teasdale 2005

The right of Jan Williams and Chris Teasdale to be identified as the Authors of the Work has been asserted by them in accordance with the Copyright, Designs and Patents Act 1988.

First published in 2005 by
HEADLINE BOOK PUBLISHING
1

Cataloguing in Publication Data is available from the British Library

Design and editorial by Perfect Books Ltd

Printed and bound in Great Britain by Butler & Tanner Ltd, Frome, Somerset

ISBN 0 7553 1447 6

HEADLINE BOOK PUBLISHING
A division of Hodder Headline
338 Euston Road
London NW1 3BH

www.headline.co.uk
www.madaboutbooks.com

For more information on The Caravan Gallery, visit www.thecaravangallery.co.uk

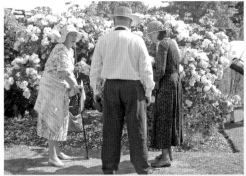

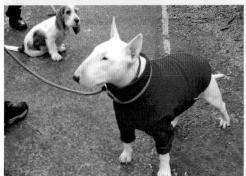

Contents

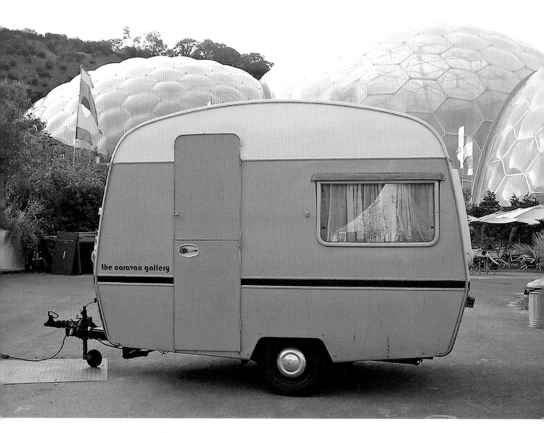

Introduction

For a number of years now, fields, car parks, villages, towns and cities around Britain, from Land's End in Cornwall to Alloa in Scotland, have been treated to the unexpected sight of a small mustard-coloured 1969 caravan sitting on its own, surrounded by tables and chairs, postcard racks, umbrellas, and dead conifers in plastic urns.

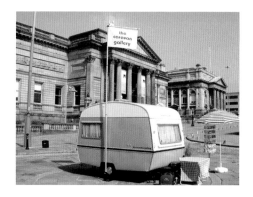

Welcome to Britain

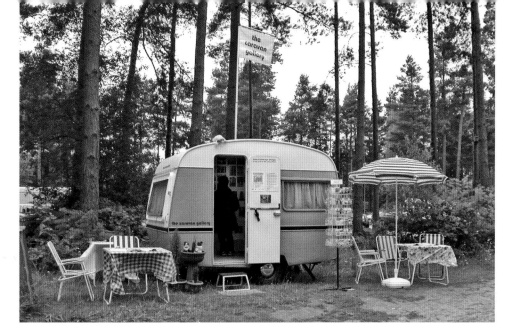

What's great about Britain?

It's the best country in the world

What's not so great?

Britain was great until they got soft

Within this unlikely setting lies a 'proper' art gallery with white walls and beech floor – and brown velour curtains: a perfect exhibition venue for the drawings, photographs and specially-made postcards produced on our mission to record the mundane, yet extraordinary, details of life in 21st-century Britain. It is called, unsurprisingly, The Caravan Gallery. A quintessential symbol of the British at leisure, it would be difficult to think of a more appropriate vehicle for displaying such an archive. 'Bobble' (our nickname, describing the Caravan's egg-like shape) reaches people that other galleries can't!

How many grand buildings have a spectacularly dead conifer outside? What is happening to our concrete car parks? Why is chicken everywhere? How many small shops are closing and why have so many churches swapped God for laminate flooring? How do people make ends meet and what does it really mean to be British? In photographing the everyday and familiar we are celebrating the overlooked details of life in Britain today. By exhibiting the results we show that there is life beyond the brown signs and Tourist Information brochures and how, by looking hard enough, unexpected delights can be found in the most unpromising situations.

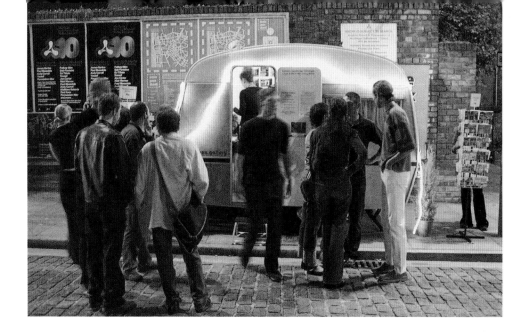

As we travel around we invite visitors to The Caravan Gallery to share their views by filling in a survey about their locality and lifestyle. With questions ranging from the serious to the frivolous, our 'subversive surveys' have always proved popular and yielded fascinating results. Other feedback comes from information left in our comments book, a fine collection of anecdotes, confessions and recommendations of places worthy of investigation.

Although we have travelled many thousands of miles and 'fetched up' everywhere from outside major art galleries to garden centre car parks, we have not, as yet, been able to cover the whole of the country (although the quest goes on). This book, therefore, serves more as a snapshot of life in Britain today, rather than a comprehensive survey, and is organised by the recurring themes that crop up wherever we happen to be. We have explored our national obsession with gardening and al fresco living, looked at curious shops and enterprises, and photographed everything from peculiar signage to knitted baked beans. We particularly enjoy recording Britain's changing architectural landscape as regeneration fever grips the

What do you collect?

Anything with cats on

Miniature shoes

Bookmarks and sugar packets

Signed drumsticks

Wives (three)

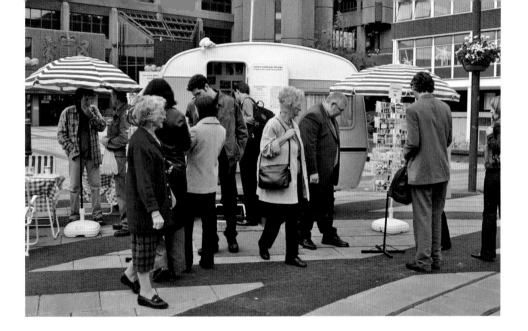

What do you think of as 'typically British'?

Seaside postcards

Thinking you're funny

It's quite chilly from time to time

White socks and sandals

nation, resulting in a heady cocktail of slick modernity and endearing shabbiness.

The photographs – many of which, by necessity, were taken at inclement times of year, in the dark, or from a moving car – need little comment from us but we have added statistics gleaned from our survey results (57 per cent of people manage to kill houseplants without even trying), answers to questions from the surveys (Q: What is great about Britain? A: Cornish pasties), and comments from the visitors' book (Can we really be like this?) to give a flavour of life in contemporary Britain.

Visitors to The Caravan Gallery often say, 'I've lived here twenty years and never noticed that.' We hope they are encouraged to look at, and appreciate, their surroundings more as a result of our efforts. They also keep asking, 'When are you going to make a book?' Well, here it is – an affectionate, pictorial documentation of the incongruous, banal and unloved, the all-too-familiar or downright bizarre features of the British landscape and people.

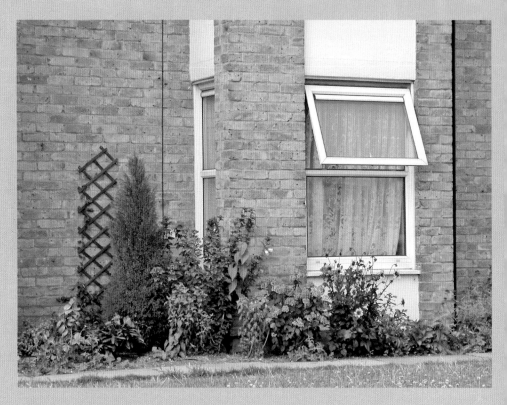

Conifers (dead)

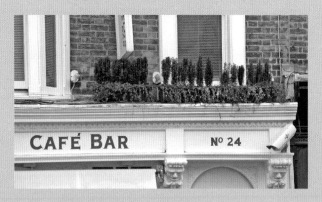

The dead conifer was adopted as The Caravan Gallery's motif because it is so ubiquitous in Britain – virtually every garden or forecourt seems to have at least one.
The dead conifer is ideal for low-maintenance gardens as it is so much easier to look after than a living plant.

Dead conifers are everywhere. We've found prime specimens from Glasgow to the Isle of Wight, often lurking in otherwise well-tended plots. You can also pretty much guarantee a good collection in every student garden, along with a few stray items of clothing.

Only 15% of people admit to owning a dead conifer

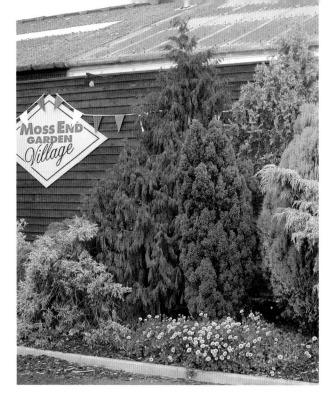

Some dead conifers stand proud as specimen plants, others try to hide in a border, while small desiccated conifers in plastic urns guard our homes.

What's great about Britain?

The green parts

What's not so great?

Net curtains

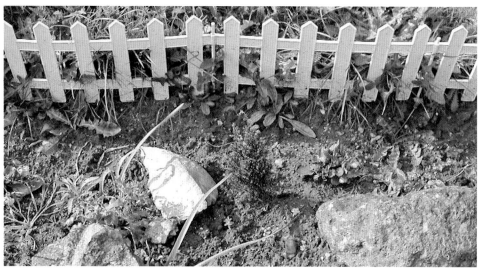

Welcome to Britain

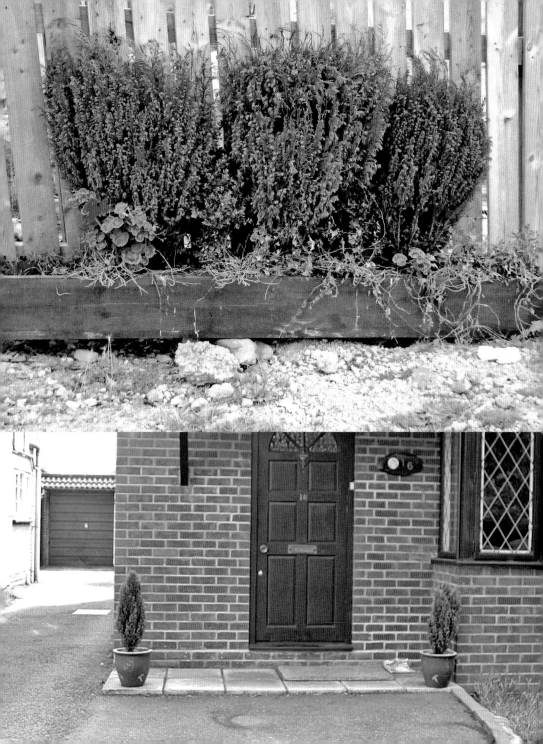

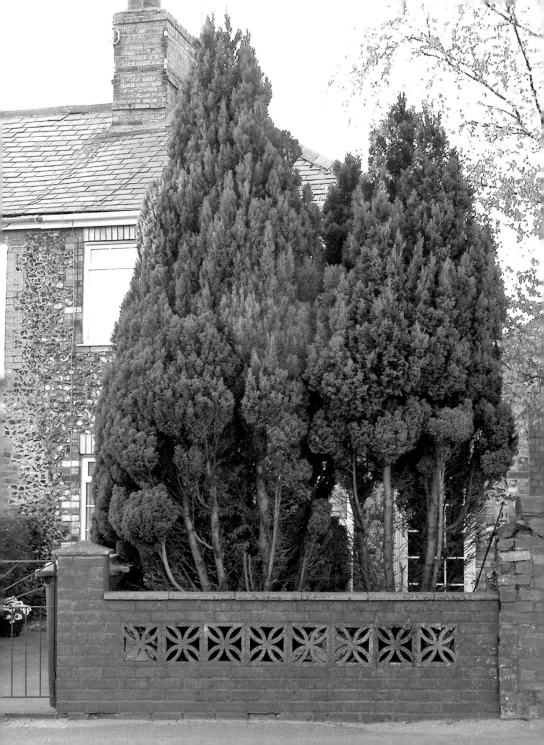

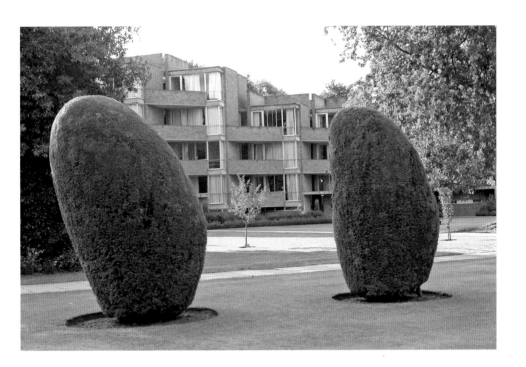

Conifers (thriving)

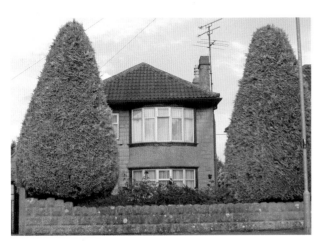

When conifer life is maintained, the results can be surprisingly spectacular. Some people feel naked without a wall of conifers (dead or alive) to hide behind, whilst others enjoy fashioning them into curious shapes.

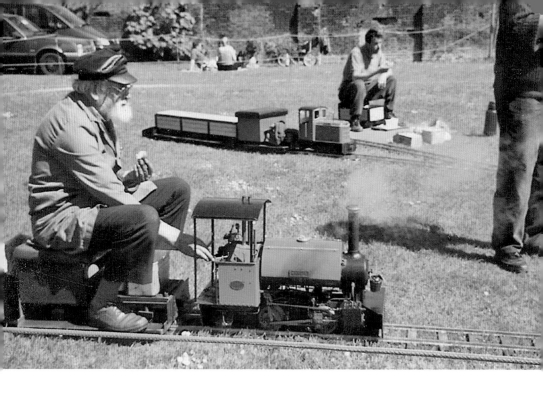

Little trains

The timeless pleasure of driving a small train over newly mown grass on a summer's day. Throw in a sandwich and a peaked cap – what more could a steamy gentleman require? Some drivers, however, may have to rely on their own steam.

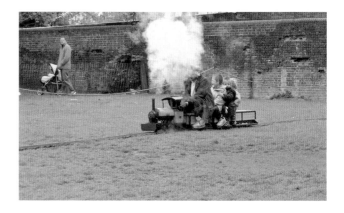

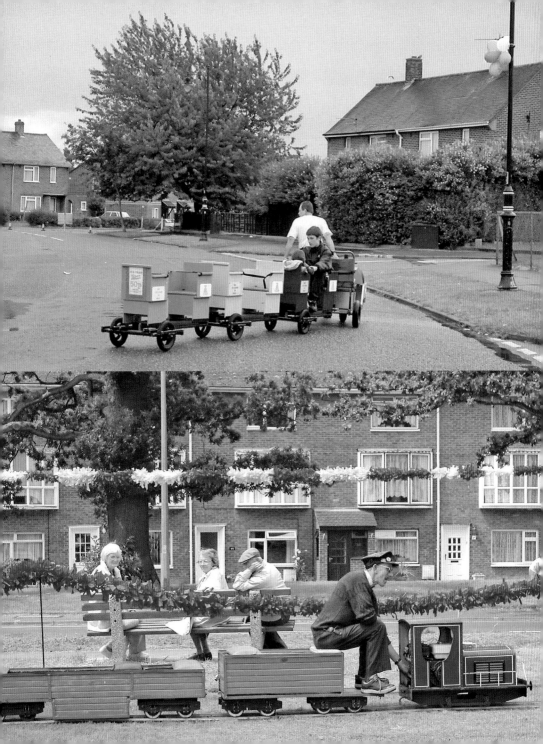

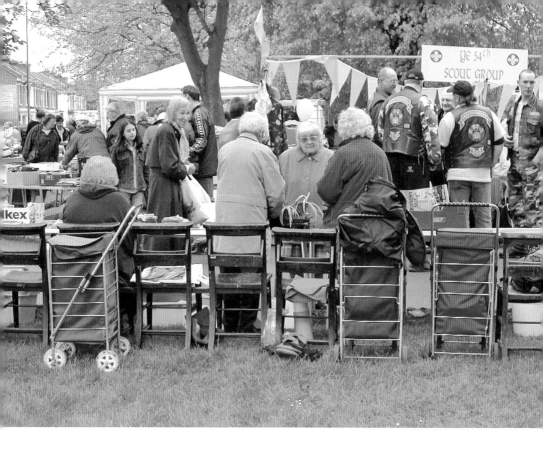

ALL TEA AND
COFFEE SERVED
IN PROPER
MUGS.

Markets

'Come on girls, get yer designer thongs here!' Victoria sponge, bramble jam, bath cubes and Battenburg cake. Gents' sports socks, Mills & Boon romances, toilet rolls (bumper packs) and designer handbags. You can get anything you want at Britain's markets, even if you don't want it. And you can always find a nice cup of tea.

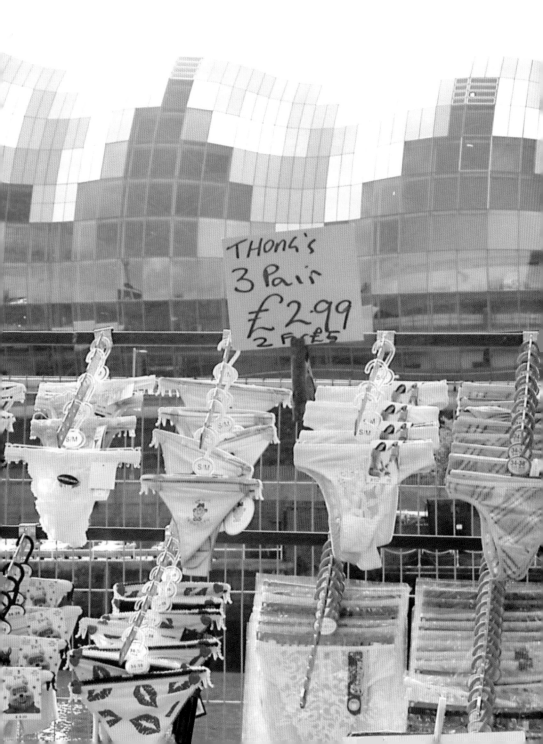

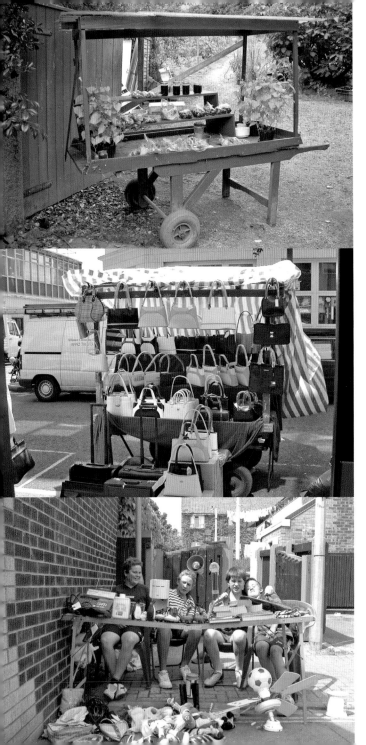

While some traders enjoy the luxury of purpose-built barrows, other resourceful entrepreneurs press spare clothes rails and sagging wallpaper tables into service.

What's the worst present you have ever received?

A horrible cup

A plastic hook set with cast plastic teddy bears

An ironing board

Welcome to Britain

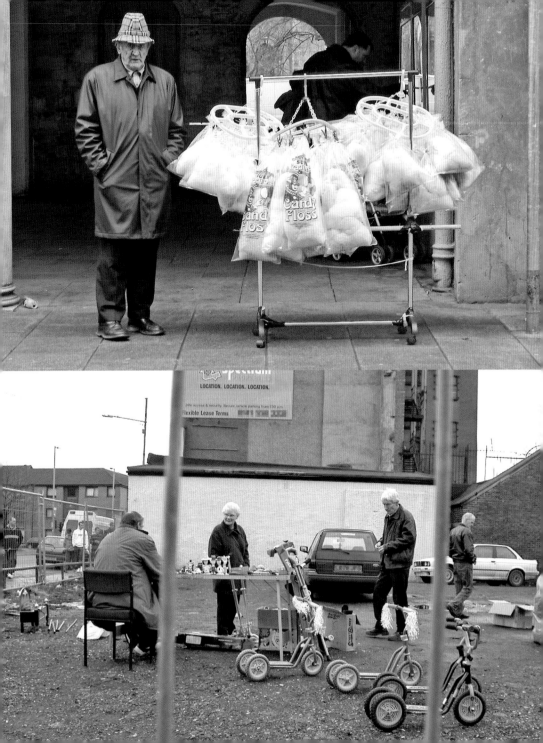

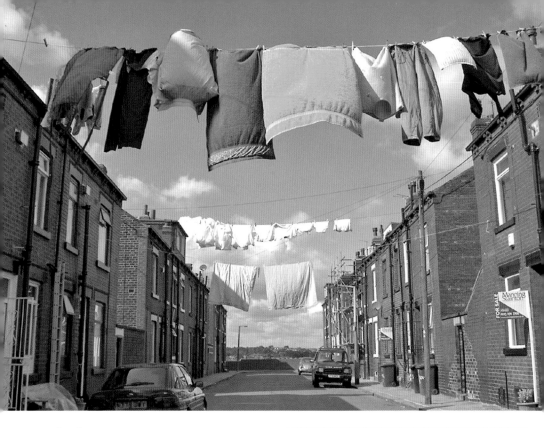

Homes

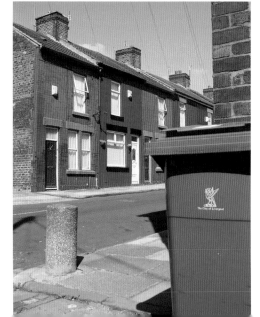

My place or yours? We live on a small island and space is at a premium, so many of us in Britain live closely packed together. And when you're living on top of each other, it helps to get on with your neighbours.

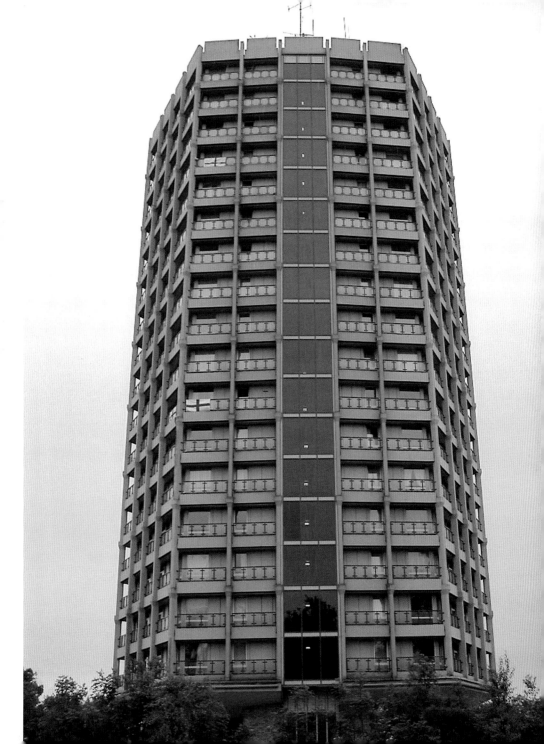

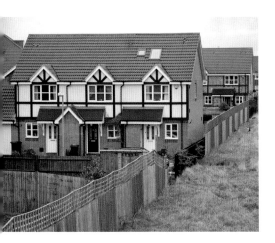

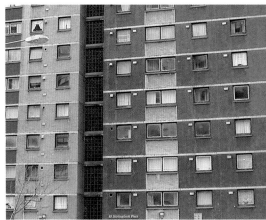

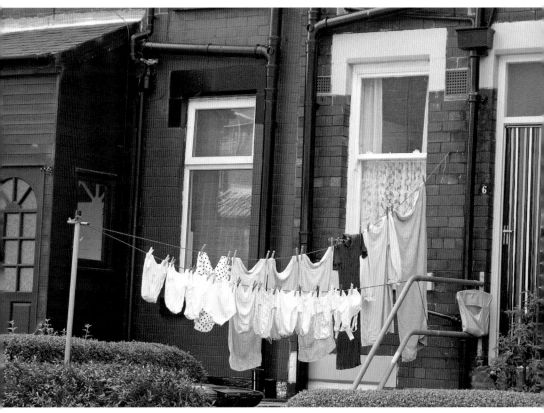

24

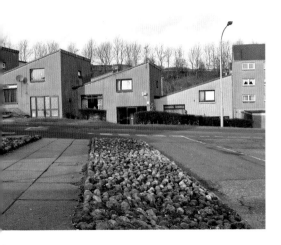

Whether it's stick-on Tudor in Slough, high-rise with multicoloured nets in Glasgow, pebble-dash in Cumbernauld, a neat red terrace in Liverpool or a cute Cornish stone cottage, there are many housing styles to choose from. Some are more unusual than others.

I wouldn't live anywhere else

What's great about Britain?

Variety and tolerance

What's not so great?

We make bad neighbours

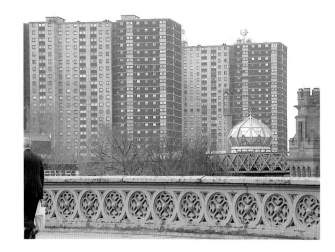

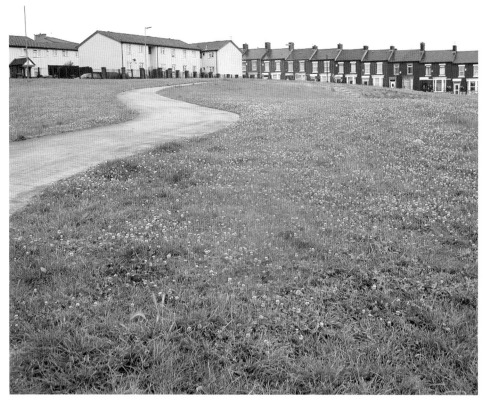

Welcome to Britain

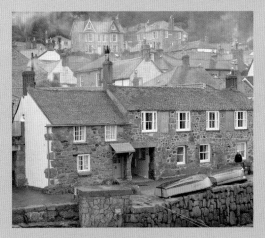
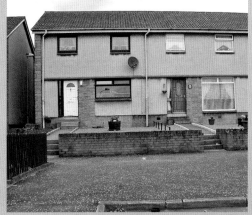
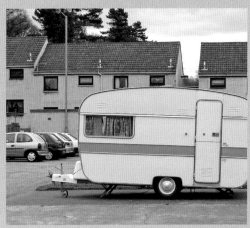

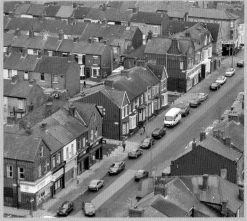

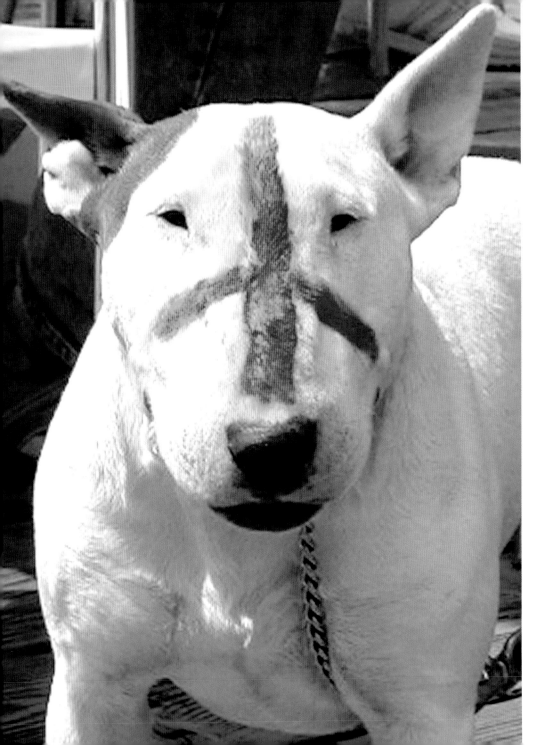

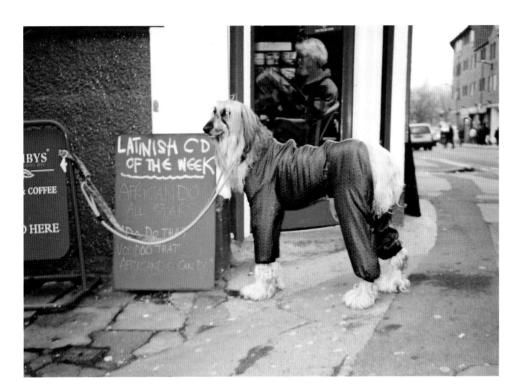

Dogs

Have you got a dog? Does it look like you? Would you go out dressed in a brown shellsuit? No? Thought not. Unfortunately, dogs have no influence over their doggy style and have to rely on the good taste (or otherwise) of their owners. Occasionally, dogs may also find themselves implicated in acts of protest.

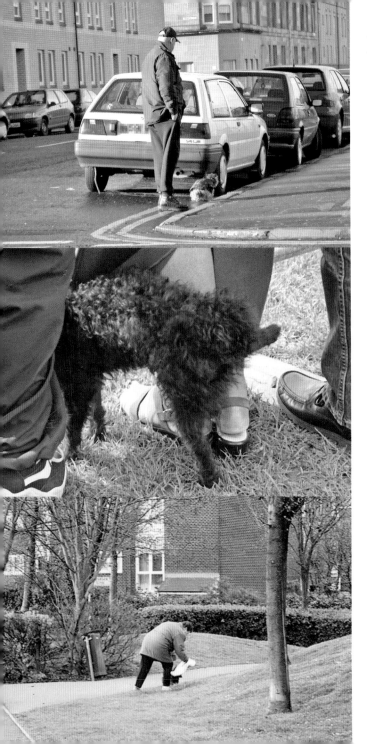

What do you think of as 'typically British'?

Rain lashing down and people waiting behind dogs with small plastic bags

What's great about Britain?

You never know what's going to happen next

What's not so great?

All the rain and too many dogs

16% of people have stepped in dog's mess in the last few weeks

Welcome to Britain

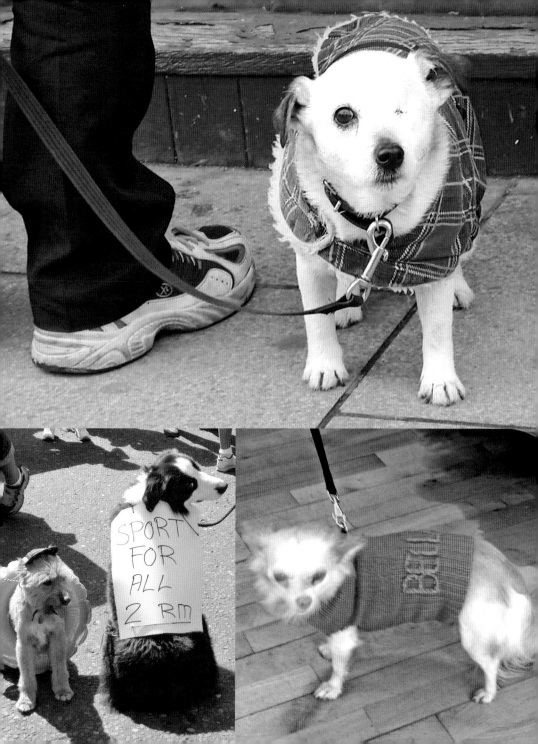

SPORT
FOR
ALL
2 RM

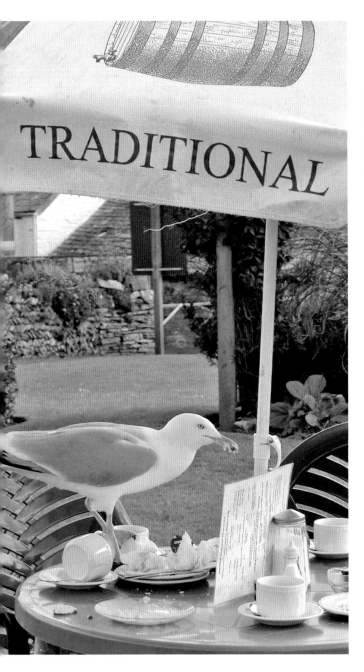

Birds

Just like the human residents, British birds enjoy cream teas and meals out, day trips with the kids and the glorious summer weather.

How do you feel about seagulls?

I shouldn't tell you but I shot six of 'em this mornin'

What's great about Britain?

I love the familiarity but hate the rain

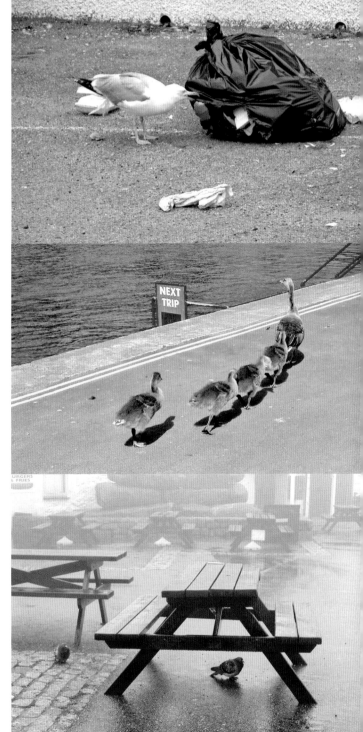

Welcome to Britain

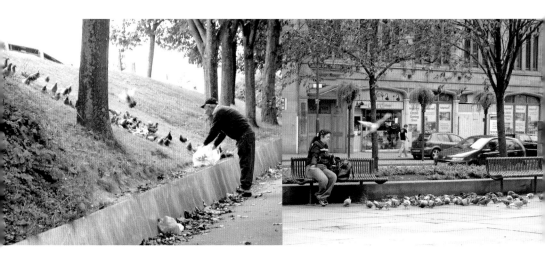

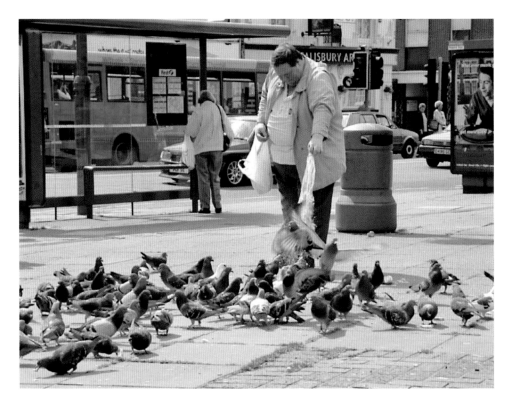

Welcome to Britain

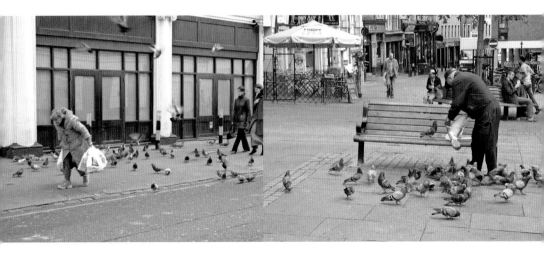

Pigeon people

Despite the signs asking us not to, there are always one or two people determined to feed the pigeons 'because someone's got to'. Every town has its pigeon feeder with a carrier bag full of old bread and an established patch for this daily ritual.

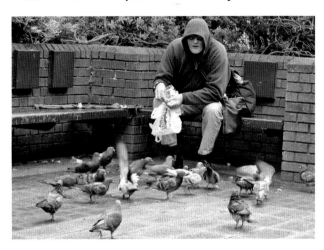

How do you feel about pigeons?

I love pigeons!

Best under pastry

I worry where their babies go

Rats with wings

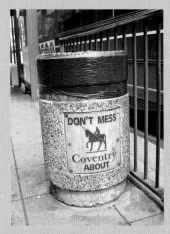

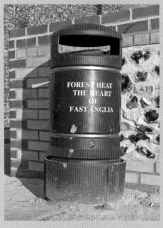

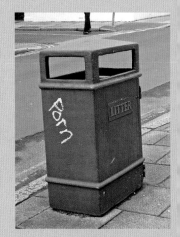

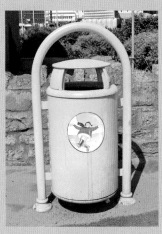

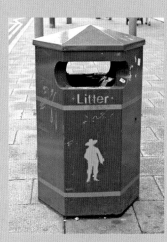

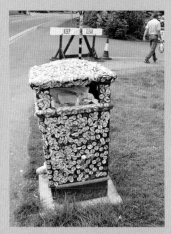

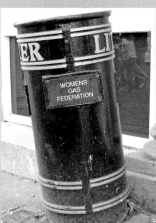

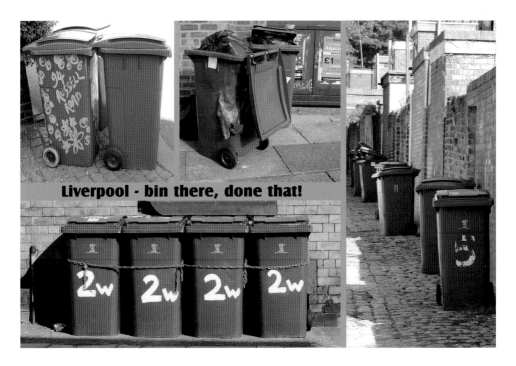

Liverpool - bin there, done that!

Bins

If you want to try and understand the character of a place, check out its bins. They can be an effective marketing tool for local councils although further 'customisation' might not always give the desired impression.

What's great about Britain?
Tea, cheese and Eddie Izzard

What's not so great?
The filth

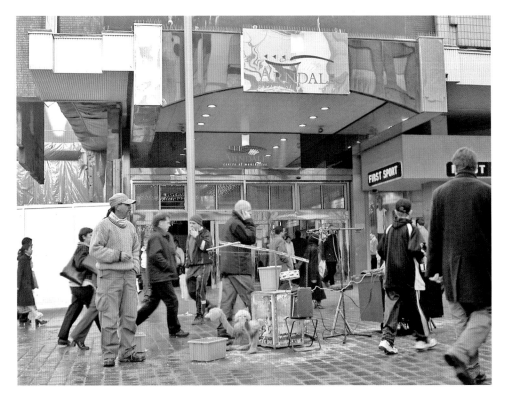

Street entertainment

In Britain people do all sorts of peculiar things on the street in exchange for money.

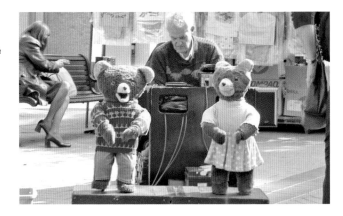

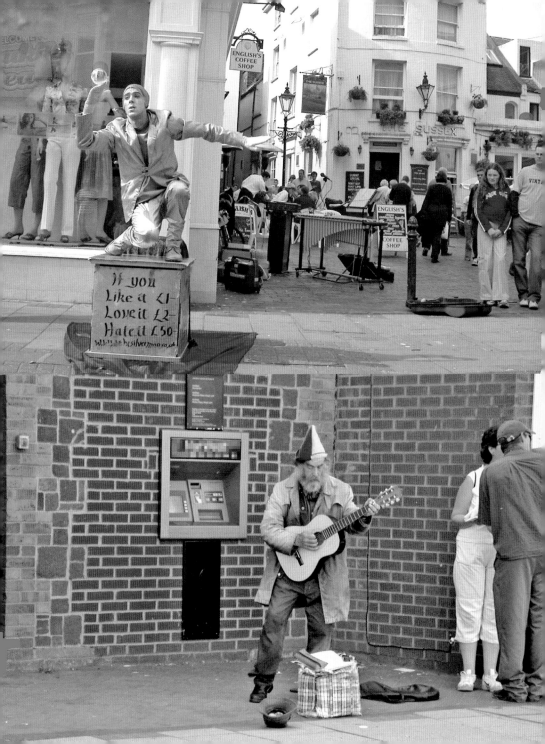

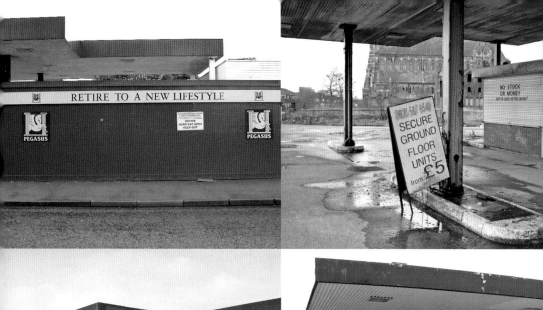

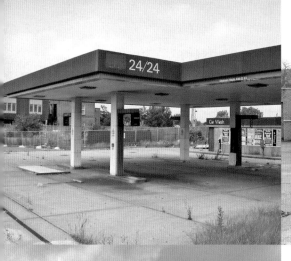

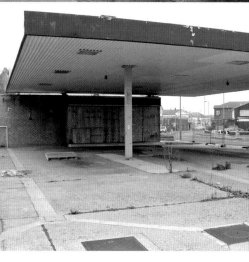

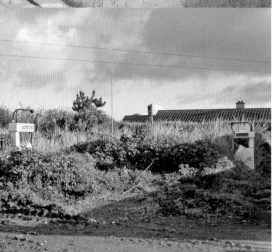

Ex-garages

A dead garage? Or a future drive-in launderette, garden centre, hand car wash, Chinese restaurant, souvenir shop, car showroom or retirement home?

Welcome to Britain

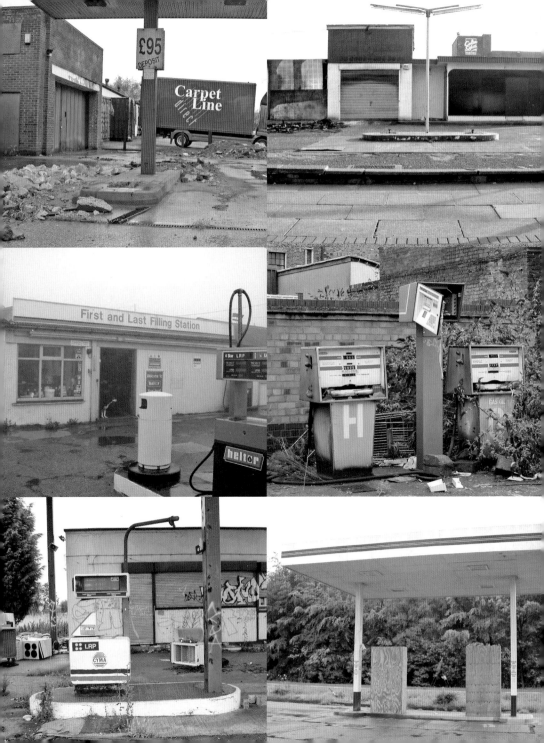

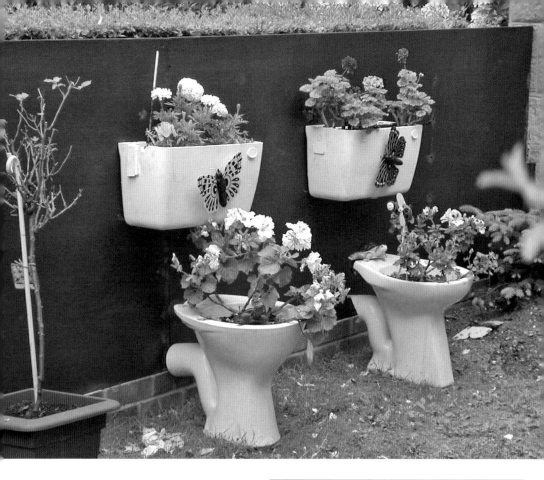

Gardens

From the humble toilet garden to the dazzling displays in our municipal parks, we British love our gardens. We all have our own ideas when it comes to creating our little bits of paradise. Some go for the low-maintenance look, using slabs and more slabs, while others prefer to use plants.

Are you influenced by home and garden makeover programmes?

Absolutely!
I turn them
off as fast
as possible

Love 'em, never
do it though

I'd like to marry
Alan Titchmarsh

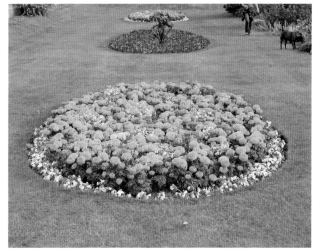

Welcome to Britain

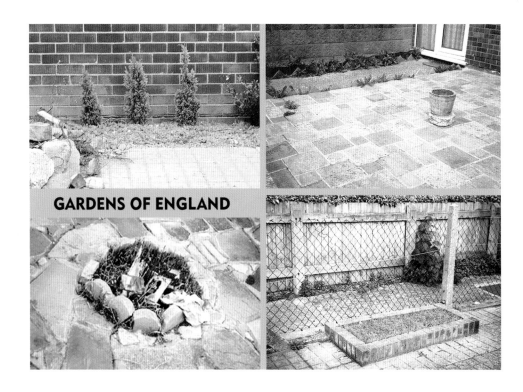

GARDENS OF ENGLAND

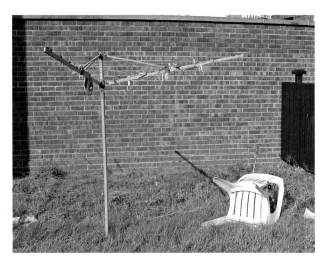

57% of people manage to kill houseplants without even trying

It's important to have a focal point to catch the eye in a garden. It could be a concrete heart, a bold display of Kniphofia uvaria or just a simple arrangement of a rotary clothes drier and plastic chair.

Welcome to Britain

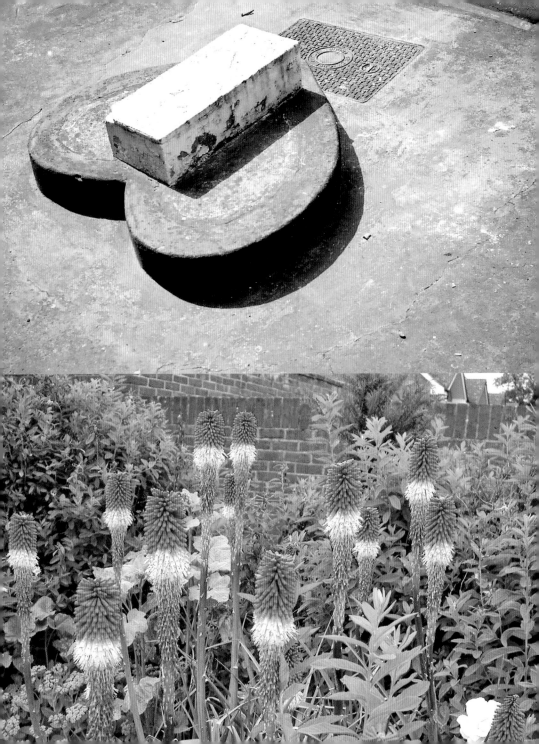

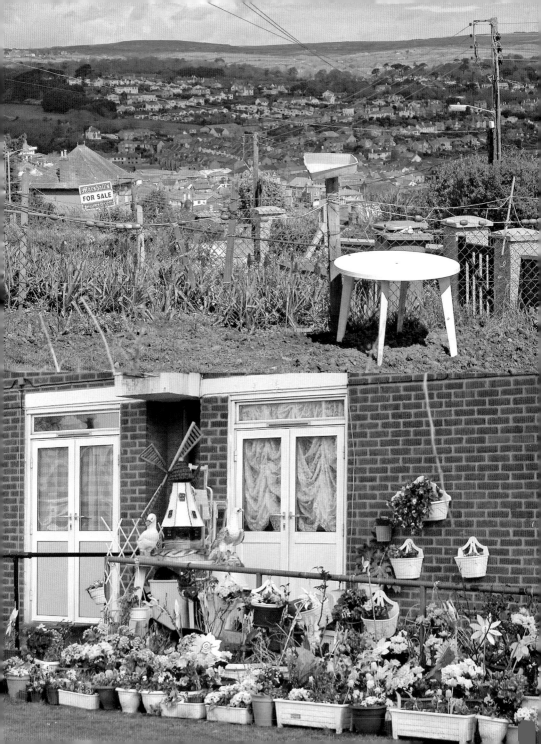

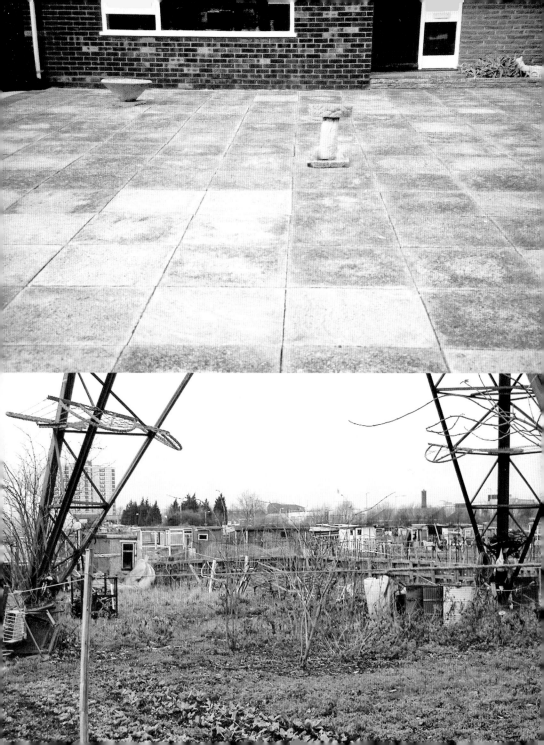

With their bright floral displays, British parks can provide a riot of colour (and useful public information) for the local bench-dwellers, but twenty years on, the International Garden Festival in Liverpool, above, is well and truly over.

What's great about Britain?

It's very green

Embracing being eccentric

Welcome to Britain

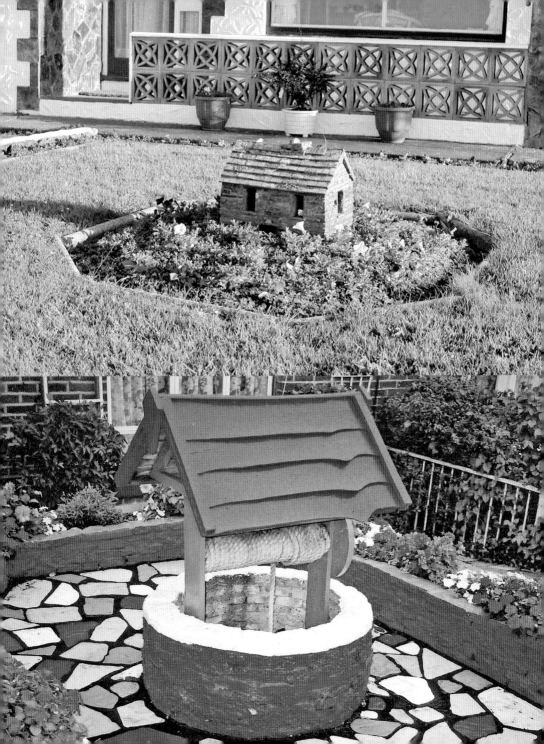

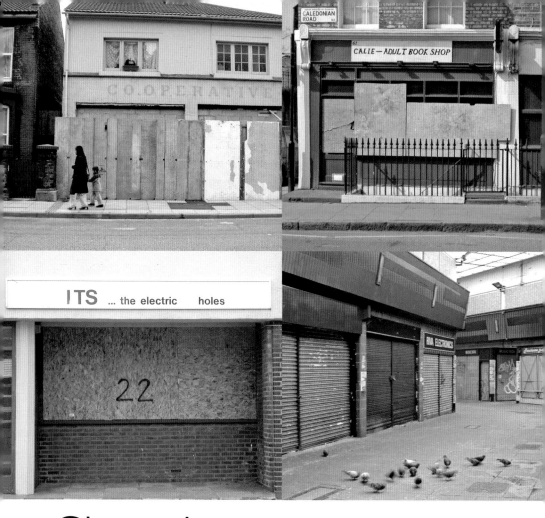

Closed

Yesterday's corner shop, today's development opportunity. Use it or lose it; it's not supermarkets that force smaller shops to close, it's the people that shop in supermarkets.

What's your personal motto?
Look on the bright side

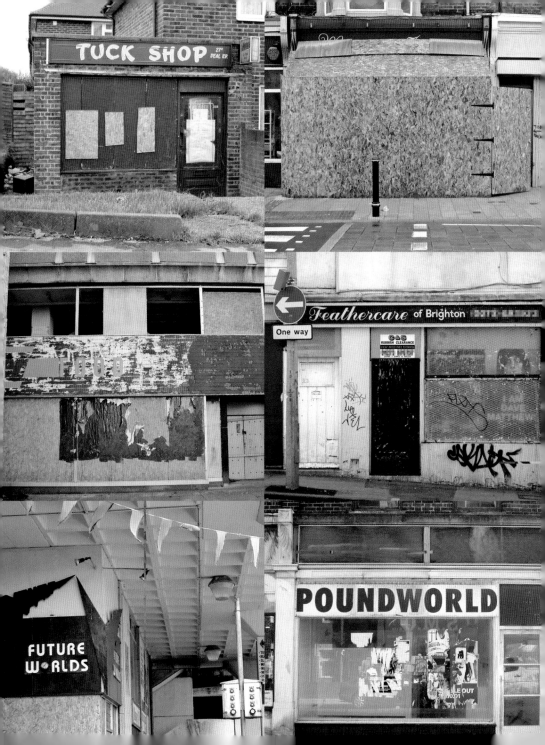

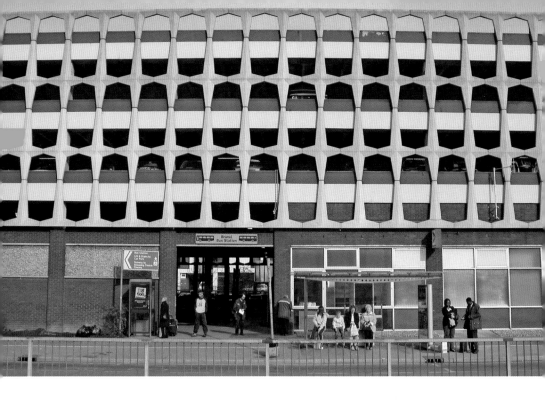

Concrete

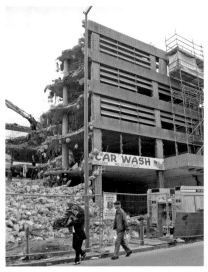

Concrete is a dominant feature of our urban landscape. Love it or hate it, people get really worked up about big concrete car parks and shopping centres, many accusing them of being dull and depressing. A few people actually think they're rather splendid.

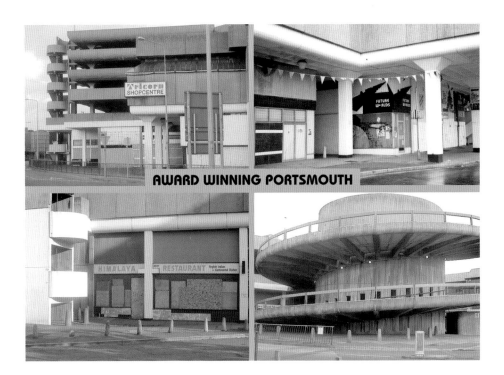

AWARD WINNING PORTSMOUTH

The Tricorn in Portsmouth won an award for being one of Britain's best examples of modern architecture. One year later, it was voted one of the worst. Like many other concrete monoliths The Tricorn has now been demolished.

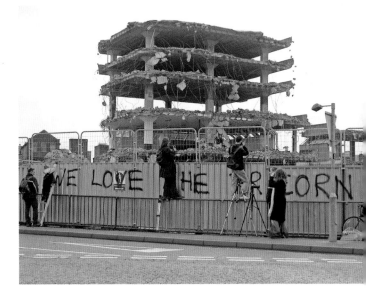

What's not so great about Britain?

Concrete

Grey days and grey days

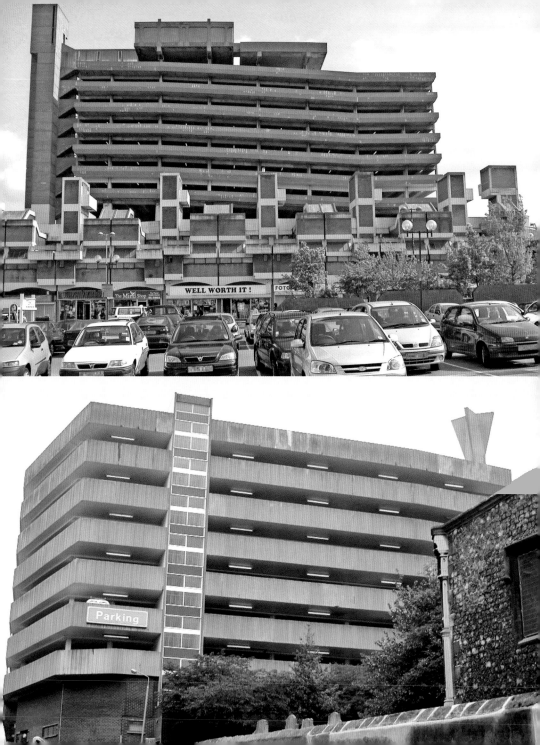

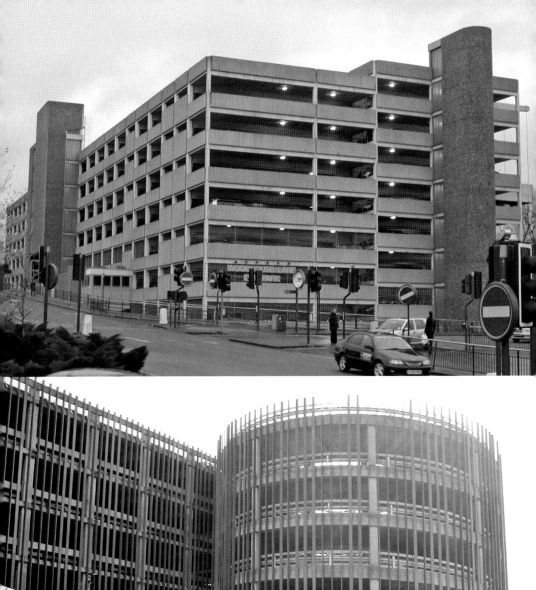

Today's news

Boiler Pervert Yob Dash Hell – screamingly over-the-top or downright bizarre, the posters on newspaper stands provide a poetic insight into our crazy world.

FRIDAY'S WEST END FINAL

MAD PERVERT WILL BE FREED

Evening Standard
www.thisislondon.com

Evening News

Evening News
NOW WITH TEETH

DANIEL O' DONNELL TICKETS STAMPEDE

THURSDAY

The News

The News
Thursday

SCANDAL OF TINY YOBS

RECRUITMENT

The News

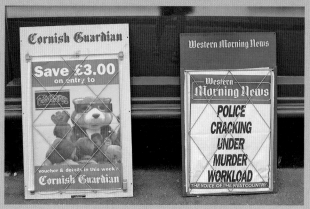

Cornish Guardian

Save £3.00
on entry to

voucher & details in this week's
Cornish Guardian

Western Morning News

Western Morning News

POLICE CRACKING UNDER MURDER WORKLOAD

THE VOICE OF THE WESTCOUNTRY

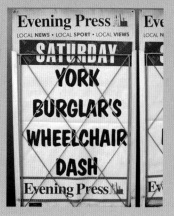

Evening Press
LOCAL NEWS • LOCAL SPORT • LOCAL VIEWS

SATURDAY YORK BURGLAR'S WHEELCHAIR DASH

Evening Press

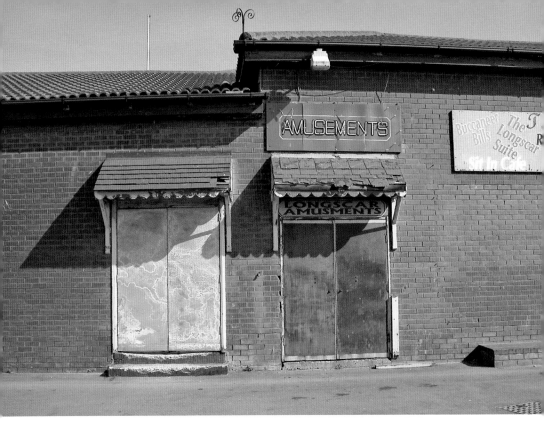

Amusements

In Britain we are expected to have fun whether we like it or not. Our coastal towns boast a wide range of amenities provided for this purpose. Fortunately, many of them are undercover – which is just as well given the high possibility of a bank holiday downpour.

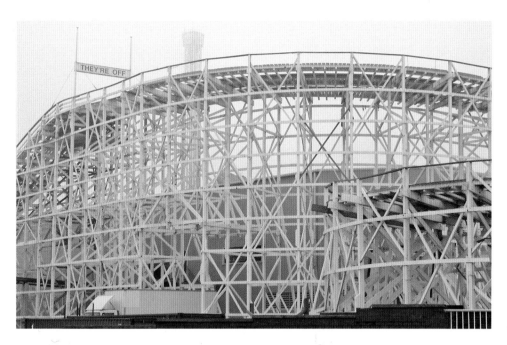

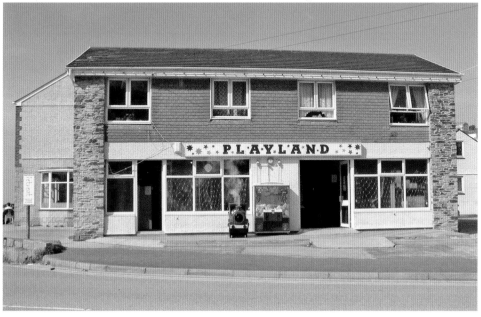

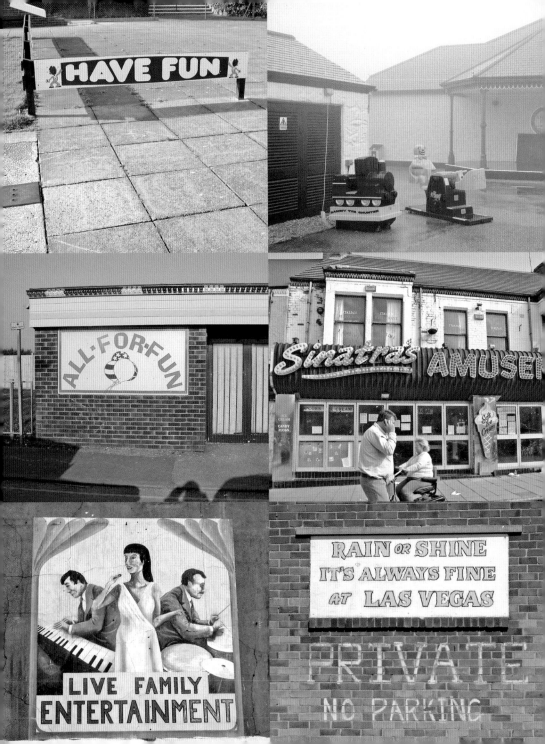

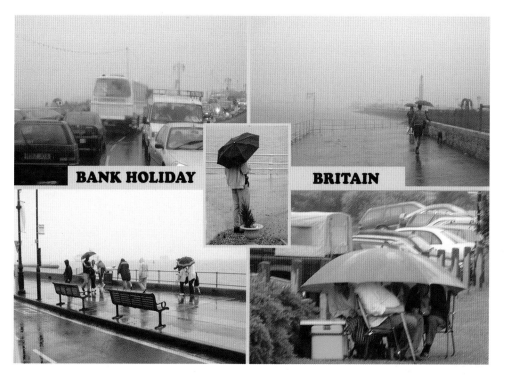

BANK HOLIDAY

BRITAIN

What's great about Britain?

Chips, curry and piers

What's not so great?

Nothing, I love old England

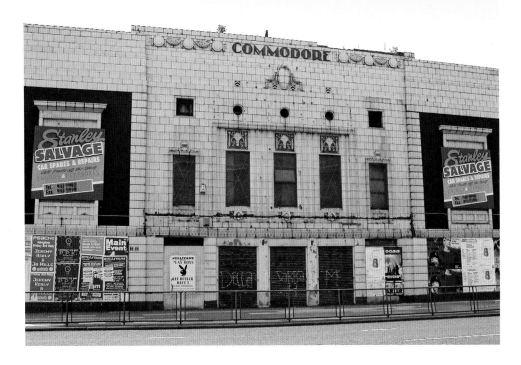

Cinemas-cum-churches

Want to buy shoes or pan scourers? Need a carpet or a beer? Fancy a game of Bingo? Chances are there will be a church or cinema near you offering these services. With features such as aisles, ushers and organs in common, it is hardly surprising to find cinemas reincarnated as churches, while churches now offer a variety of secular facilities.

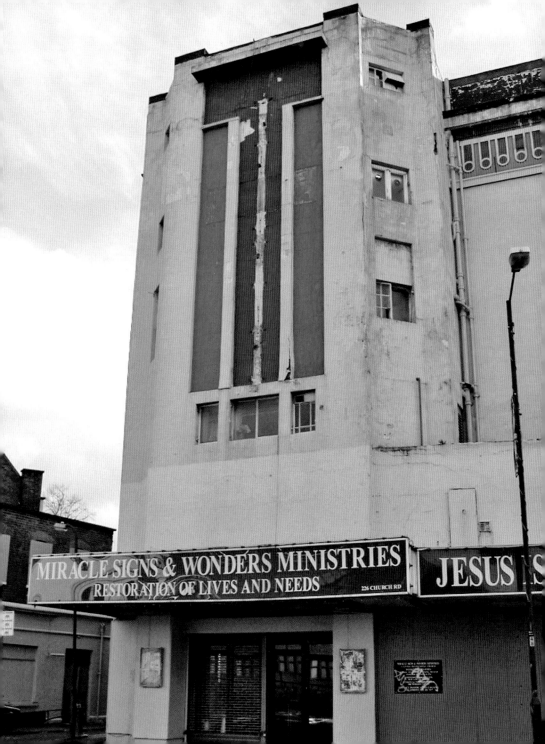

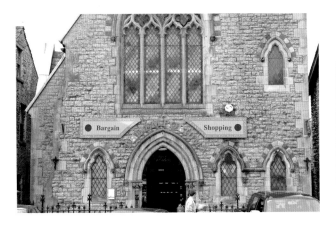

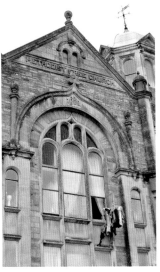

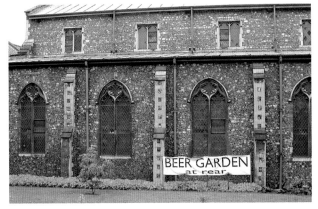

Many churches have diversified to provide accommodation, retail or pub services; those that retain their congregations find that investment in security helps to keep their prayers safe.

99% of people would rather die than arrange a pre-paid funeral

Welcome to Britain

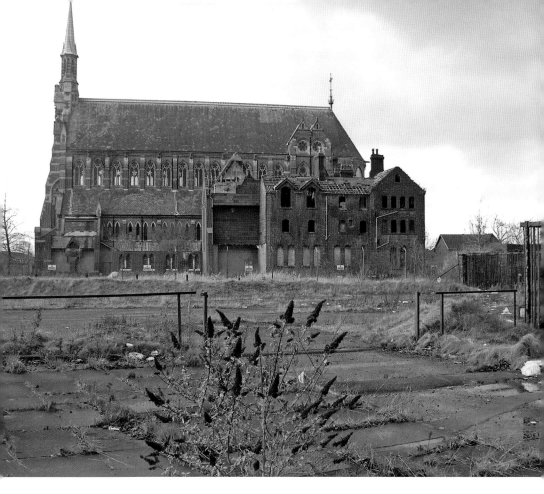

The huge edifice of the Gorton
Monastery in Manchester – the
'Taj Mahal of the North', above –
is on the list of 100 Most
Endangered World Monuments,
along with the Valley of the
Kings and Machu Picchu.

Welcome to Britain

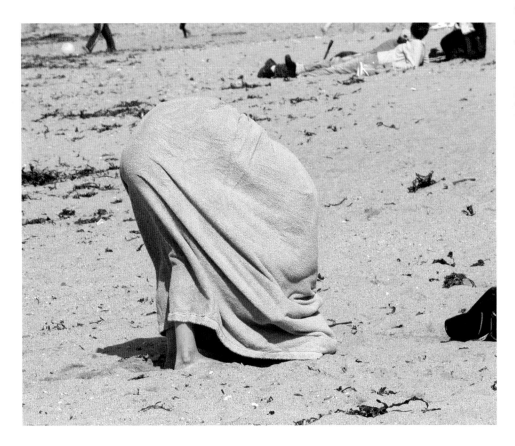

Seaside

The ideal place to park up, read the paper, have a nap and a flask of tea, all without leaving the comfort of your vehicle (except to purchase an ice cream to enjoy whilst gazing out to sea through the windscreen). Some people go to the seaside to drink lager and eat chips. Other beach-lovers arm themselves with tents, windbreaks and other accoutrements so they can be private in public; the more bashful avoid drawing attention to themselves by clever use of a large towel.

What's great about Britain?

The reticence and modesty of its people

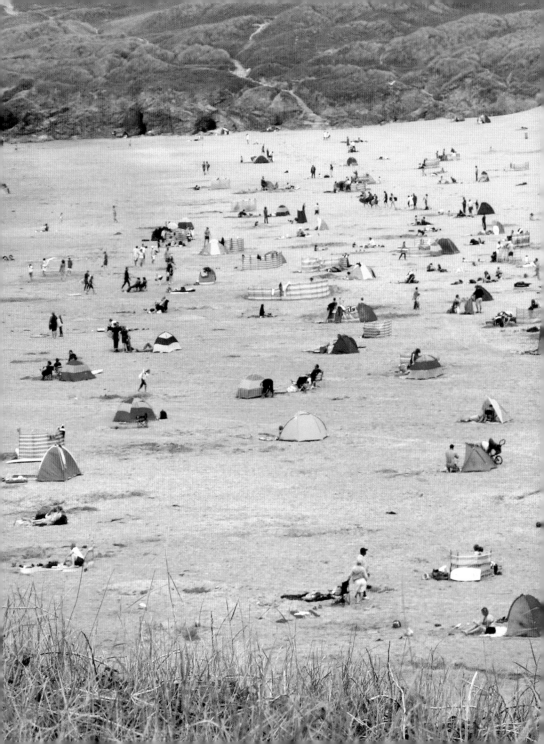

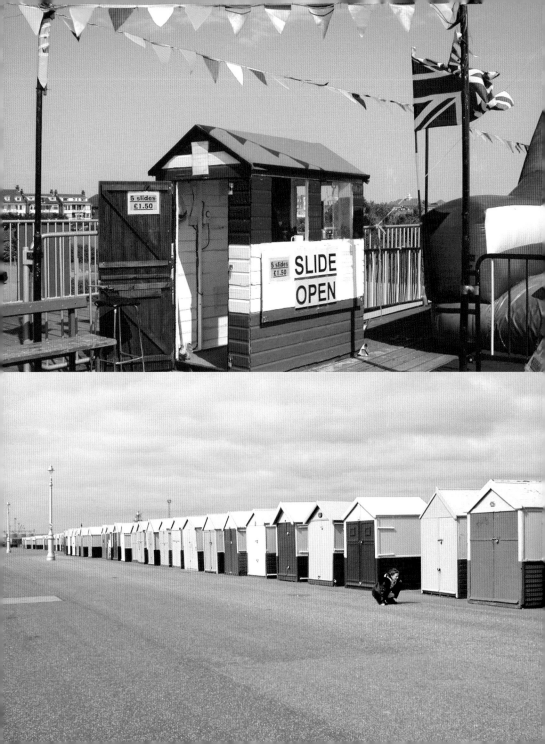

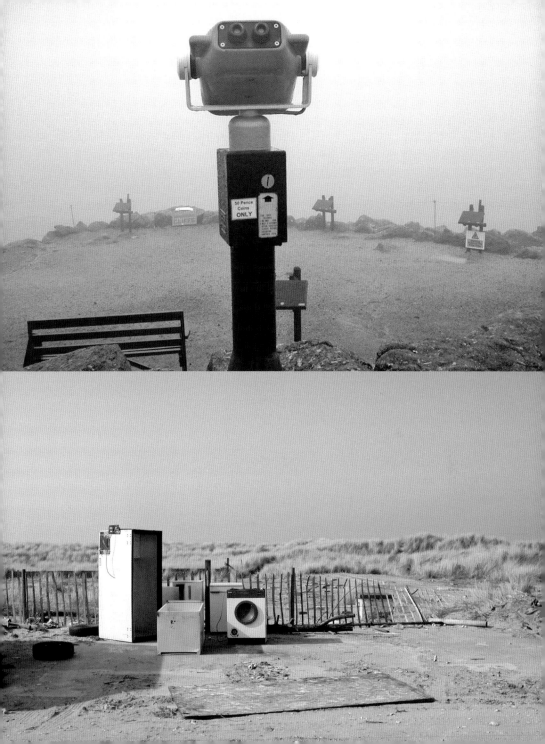

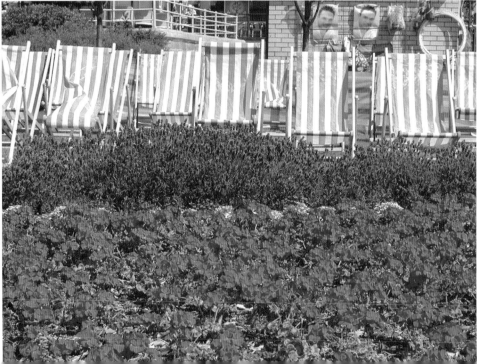

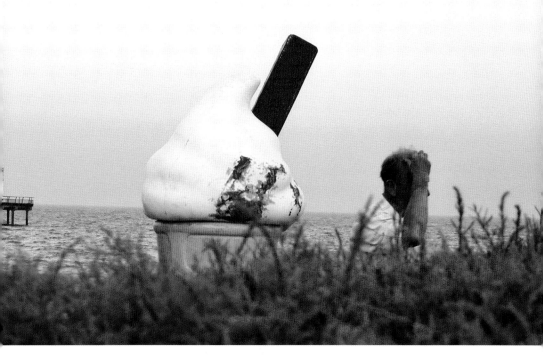

What's great about Britain?

The edges

What's not so great?

The middle

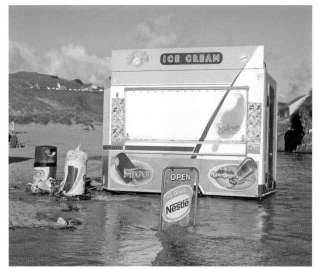

I love being British abroad; at home I would rather be French

Welcome to Britain

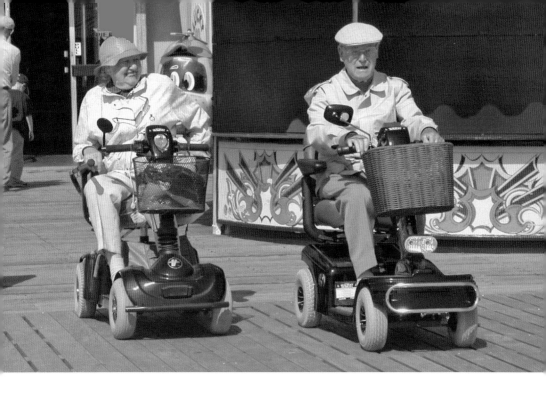

Getting about

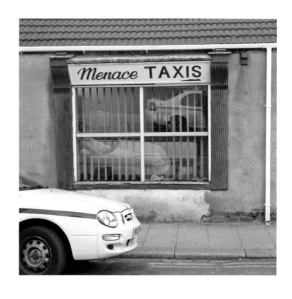

With growing congestion on the roads and the scourge of overzealous traffic wardens and clampers, it might be worth considering other modes of transport. How much more pleasant to relax in a lovingly maintained bus shelter or glide in tandem down the pavement on your scooters.

Welcome to Britain

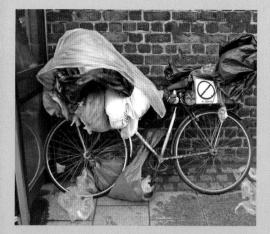

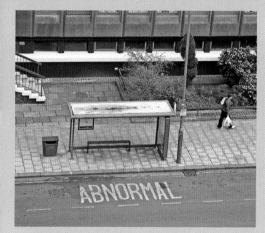
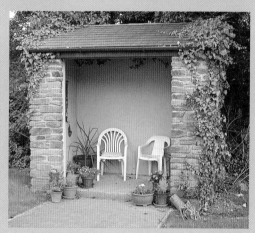

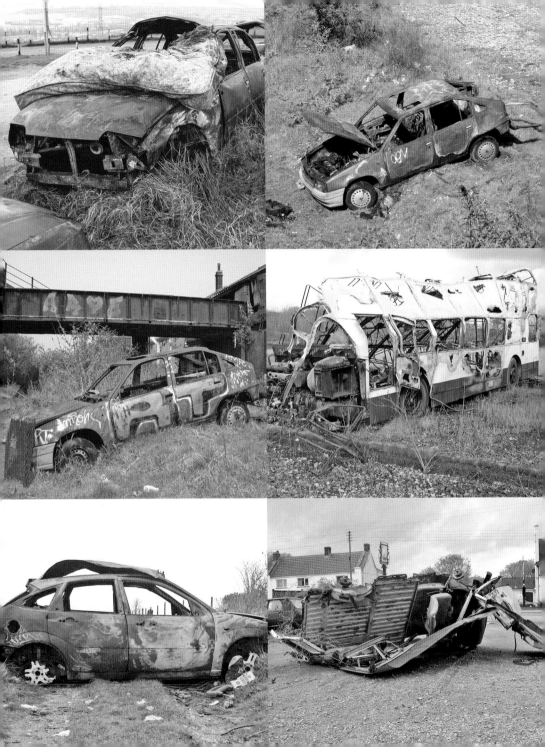

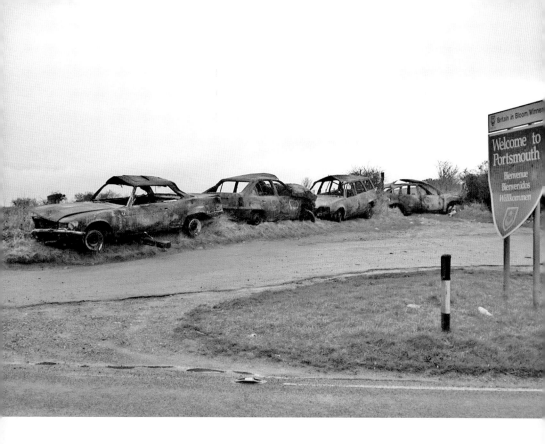

Ex-transport

A familiar sight in rural areas,
the sculptural presence of
burnt-out cars lends the
countryside a sinister air.
How did they get there?
What happened?

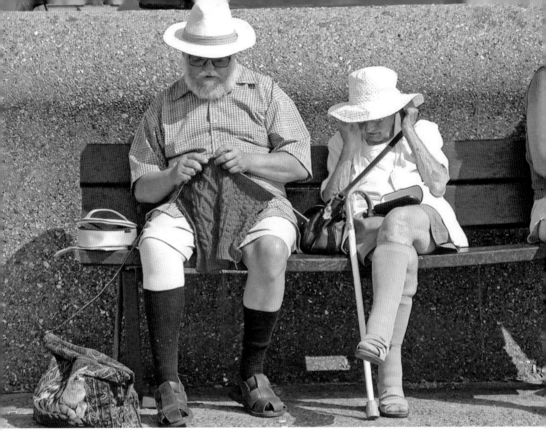

Relaxing

The British have perfected
the art of relaxation over
centuries. They excel at
making themselves at home
in any situation, oblivious
to the sensibilities
of onlookers.

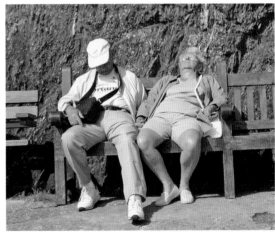

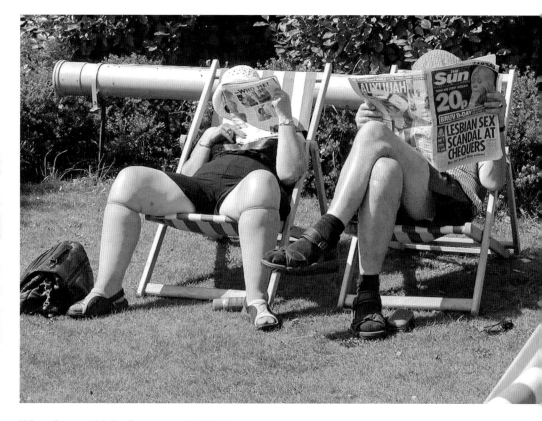

What do you think of as 'typically British'?

A view, a brew and a loo

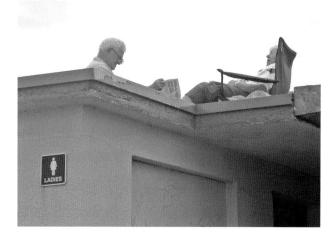

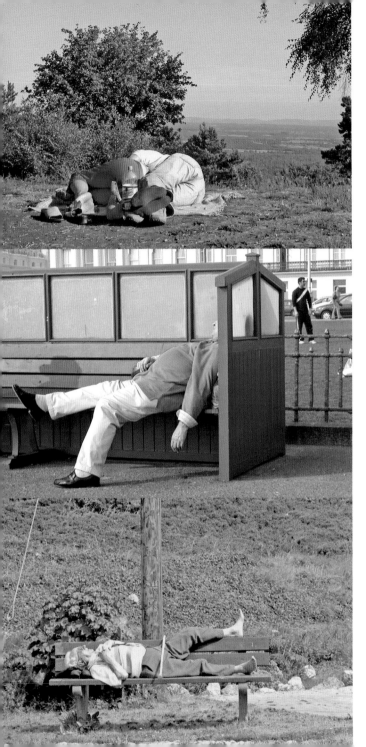

30% of people have never seen their parents naked

What do you think of as 'typically British'?

Fat people with sunburn

Certain standards

Making the most of it

Welcome to Britain

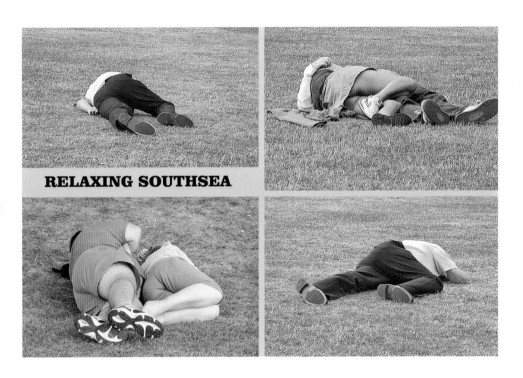

RELAXING SOUTHSEA

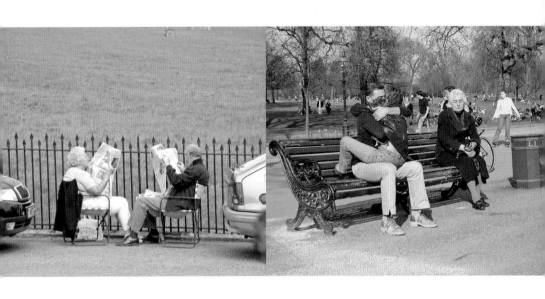

Welcome to Britain

Public houses

Beer and fags, Sky TV, karaoke, exotic dancers, raffles, quizzes, chicken and chips, Phil Collins on the jukebox, patio gardens, fake wood beams, nightmarish carpets, bleak family rooms, that special toilet smell. Marvellous!

What's great about Britain?

Fish and chips and pub gardens, real ale

What's not so great?

Done-up pubs, keg beer, lager louts

17% of people have won meat in a raffle

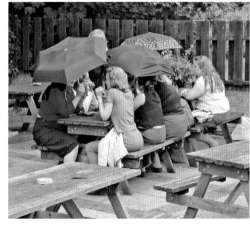

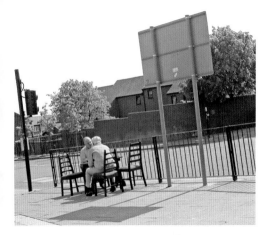

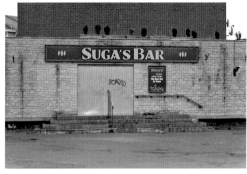

What's your personal motto?
You can't fall off the floor

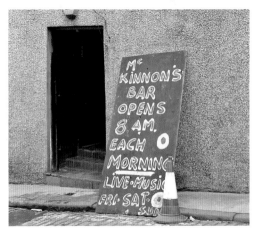

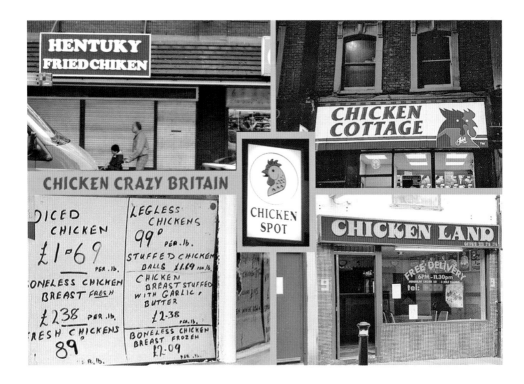

Chicken

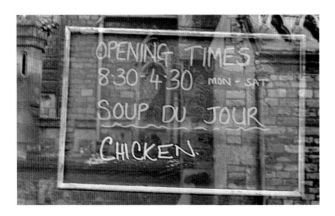

Chicken is storming the nation. Pay attention and during the average British day you will see and hear at least twenty-three references to chicken. A typical example: 'I don't eat meat – just chicken.'

79% of people enjoy chicken

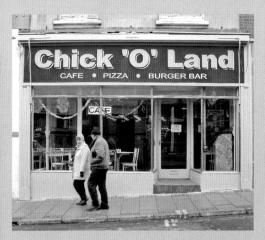

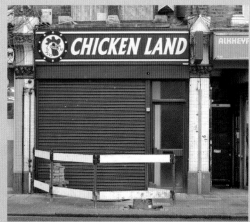

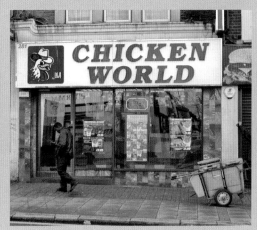

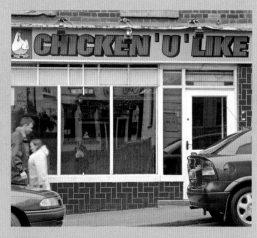

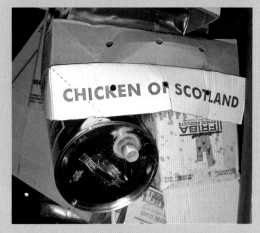

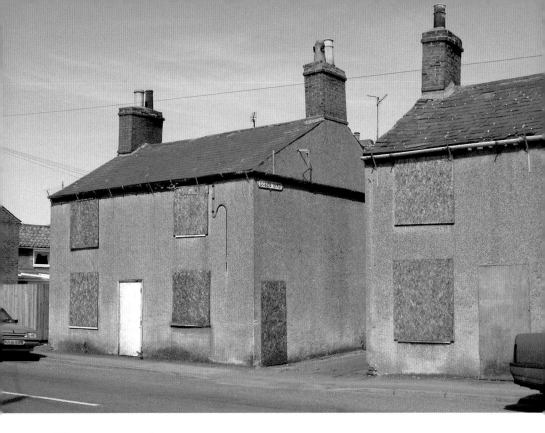

Dereliction

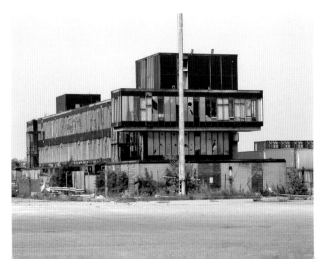

A precursor to regeneration – which may or may not be an improvement.

Welcome to Britain

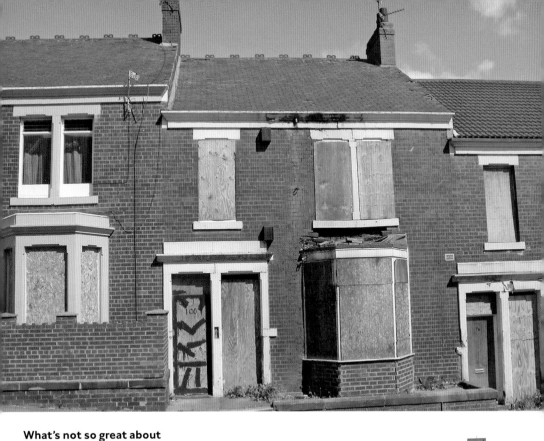

What's not so great about Britain?

Disappearing fields, roadworks and hospital waiting lists

Let's be honest – it's slipping a bit

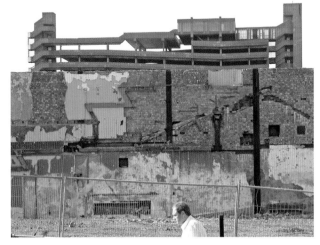

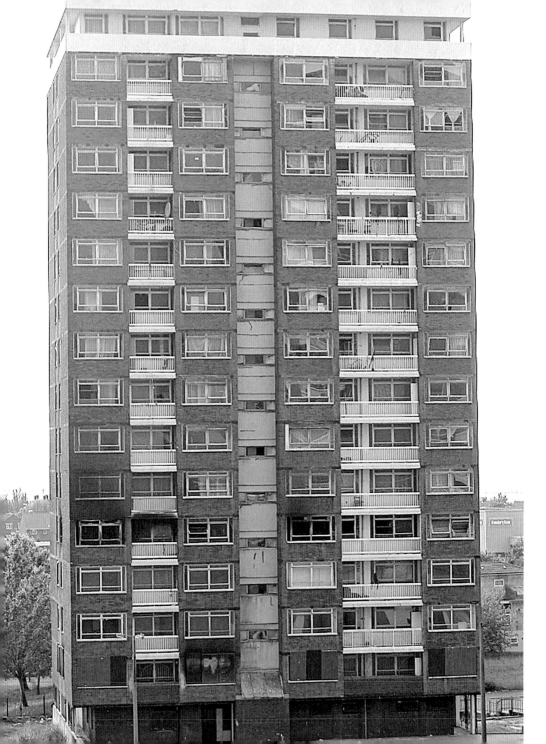

Tower block and ex-tower block in Liverpool – an acre of mud marks the half-way point between dereliction and regeneration. And it looks like poor Glenda needs a new theatre.

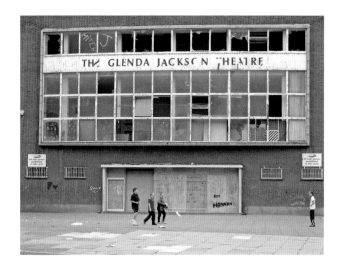

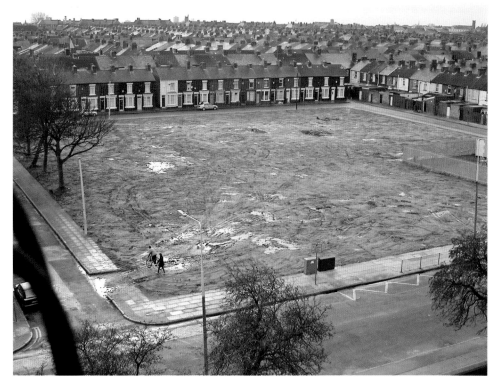

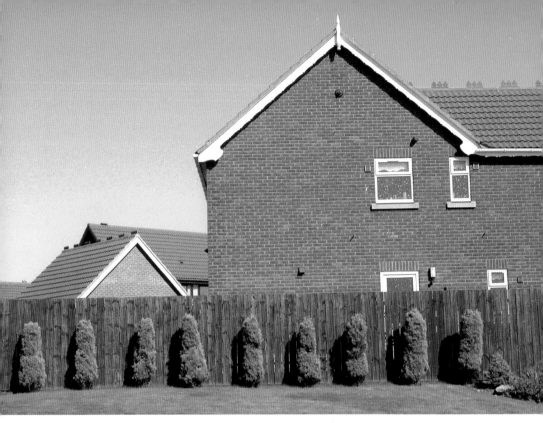

Regeneration

Follows dereliction –
which may or may not
be an improvement.

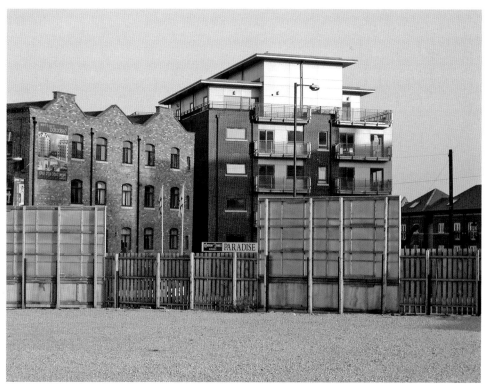

Last week a wasteland, next week a luxury development for those seeking prestigious designer executive lifestyles.

What's your personal motto?

It'll all be OK in hindsight

Welcome to Britain

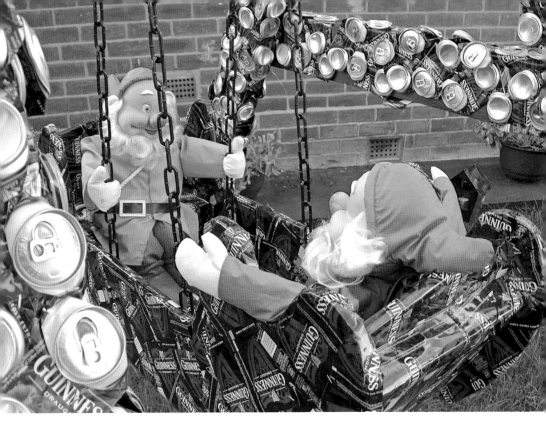

Ornamentation

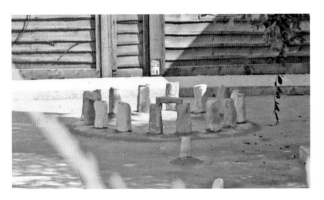

Unleash your creative energies when choosing your garden ornament. A majestic lion or bawdy gnome could be just the thing to perk up your patio. And it's funny how Stonehenge always looks smaller than you expect.

Welcome to Britain

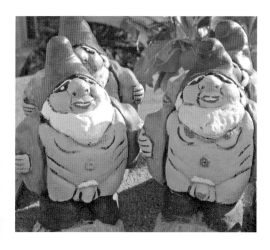

I heard about a
Battenburg cake
Stonehenge held together
with cocktail sticks

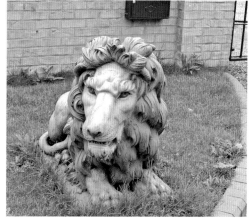

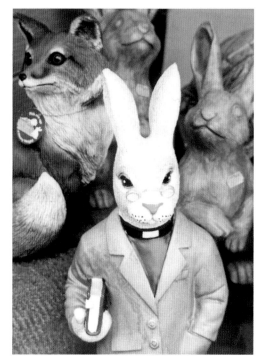

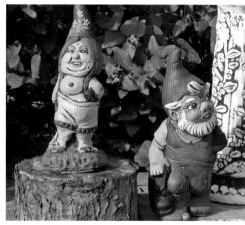

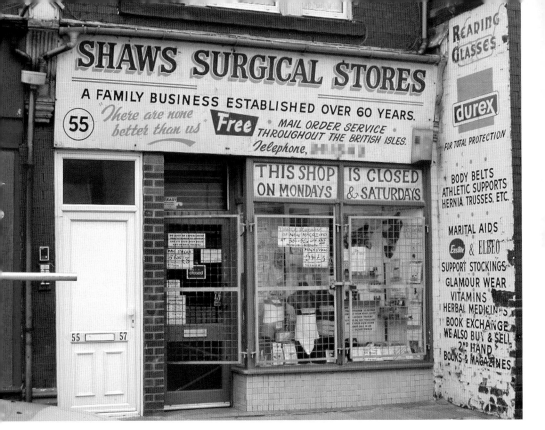

Shops

Shopping is our favourite pastime and there's nothing we like more than a bargain. Buy one, get one free!

18% of people avoid their neighbours while out shopping

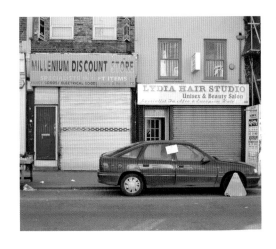

Welcome to Britain

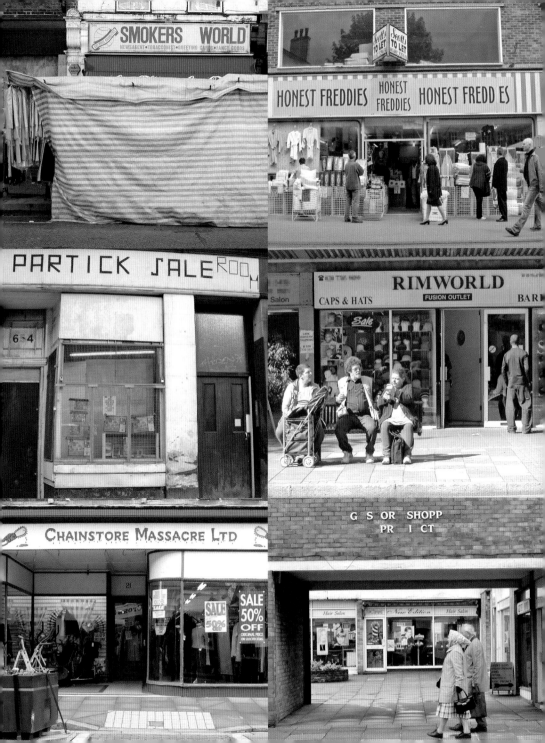

28% of people buy things they don't like because they're cheap

Welcome to Britain

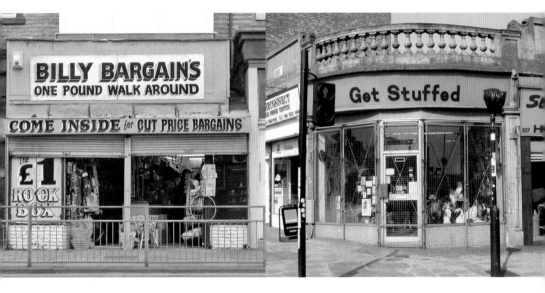

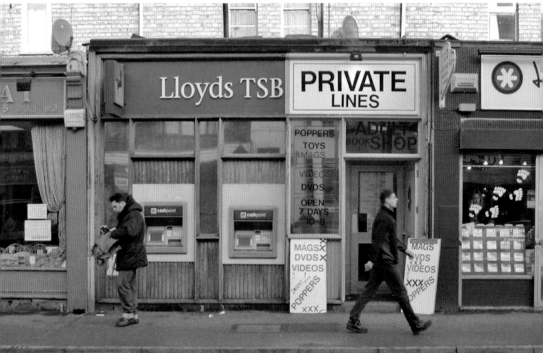

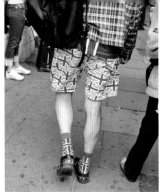

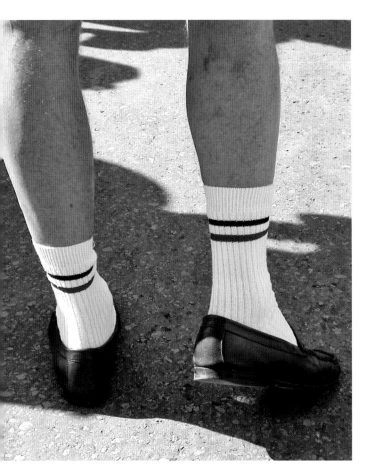

What do the people of Britain wear in summer?

Not enough or anything that is too small for them

There's a man in Huddersfield who has a hat made entirely out of old chewing gum

Fashion

The British like to express their individuality in their choice of clothes. Attention to detail can make all the difference to an outfit.

Welcome to Britain

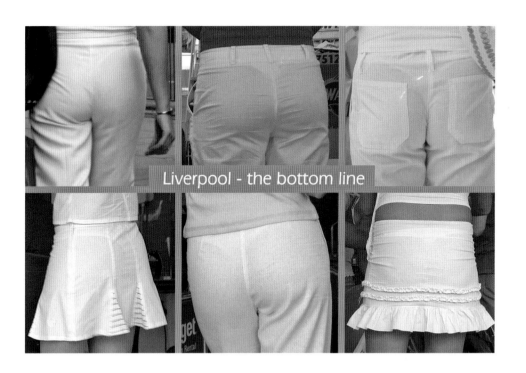

Liverpool - the bottom line

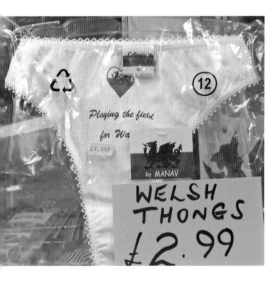

WELSH THONGS £2.99

Side by side

**Curious juxtapositions –
happy accident or bad design?
Britain is full of houses
neighbouring car parks,
pubs tucked under office
blocks and fishermens' huts
opposite steelworks.**

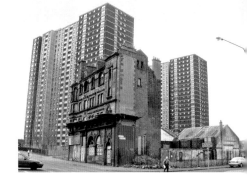

Welcome to Britain

What's great about Britain?

The mixture

What's not so great?

Living in
the past

Welcome to Britain

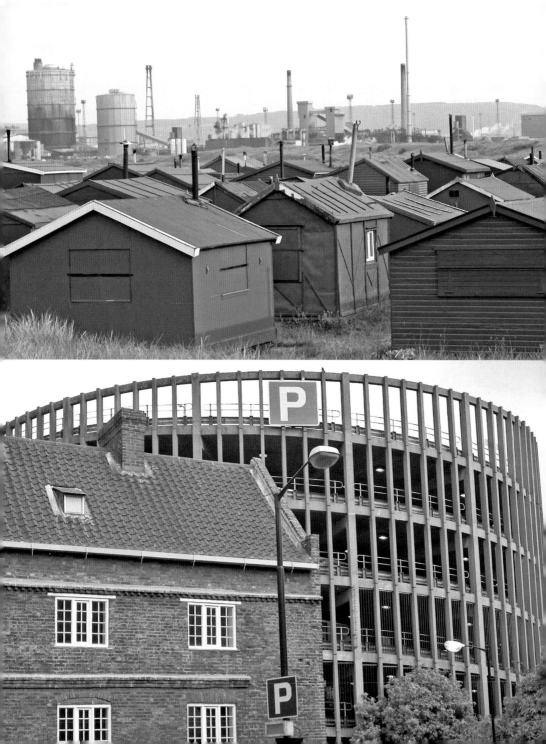

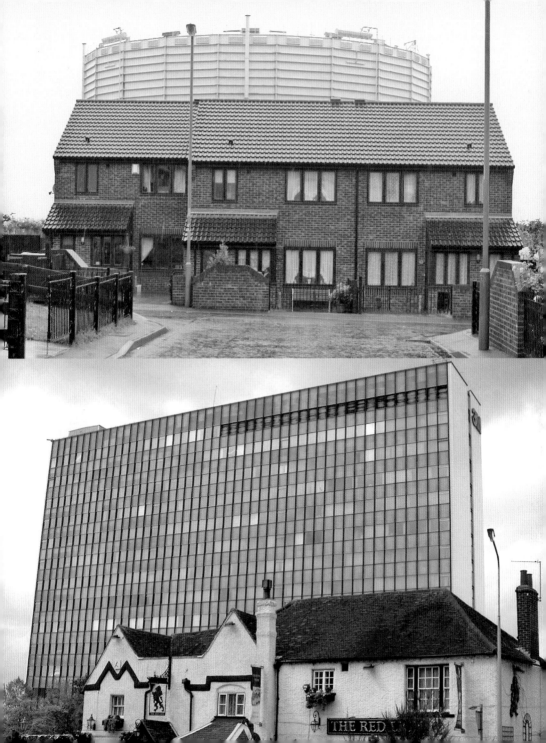

ANIMAL LOVING BRITAIN

Showgrounds

Fun for all the family! Where else can you meet goat lovers, buy a mop, smash a plate, acquire a stuffed hippo, win a coconut, watch a man demonstrate a peeling-slicing thing, purchase fudge, have a beer and use a Portaloo? At one of Britain's many local shows, of course.

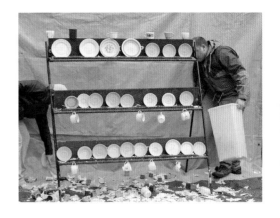

Welcome to Britain

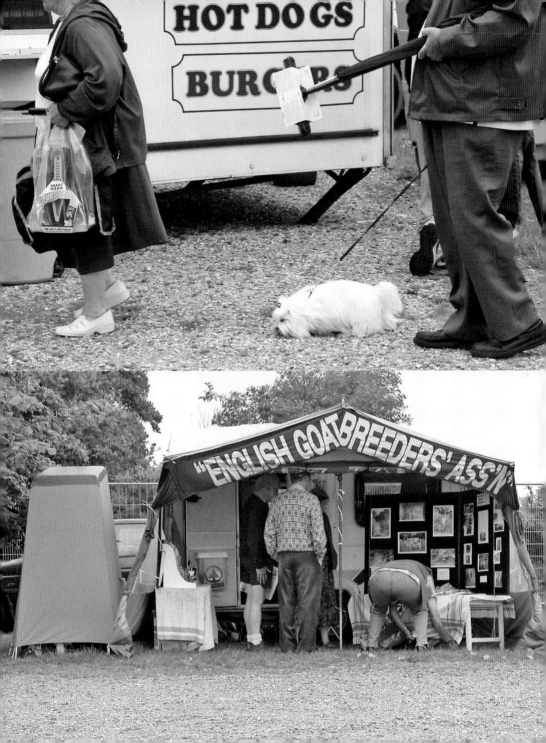

Signs

Got something to say? Make a sign. Got something to sell? Make a sign. Got a gripe? Make a sign. Want to know where you are? Look for a sign. Got something to show off about? Make a sign. Has somebody upset you? Make a sign!

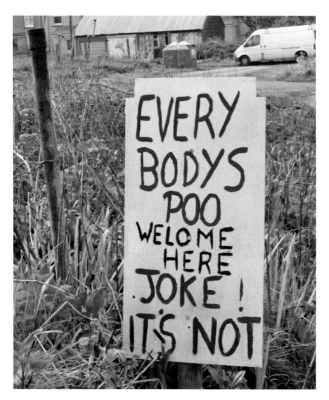

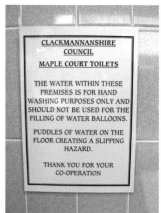

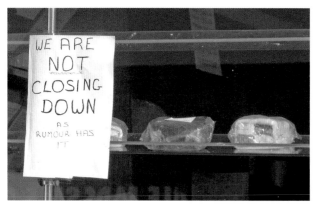

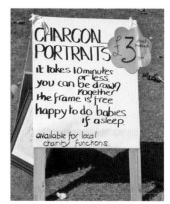

Welcome to Britain

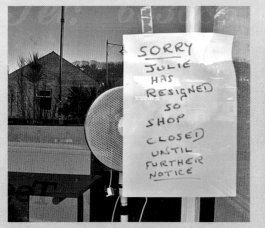

SORRY
JULIE
HAS
RESIGNED
SO
SHOP
CLOSED
UNTIL
FURTHER
NOTICE

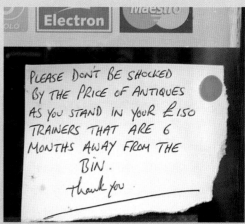

Electron

PLEASE DON'T BE SHOCKED
BY THE PRICE OF ANTIQUES
AS YOU STAND IN YOUR £150
TRAINERS THAT ARE 6
MONTHS AWAY FROM THE
BIN.
thank you

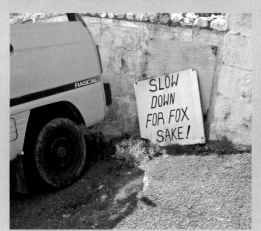

RASCAL

SLOW
DOWN
FOR FOX
SAKE!

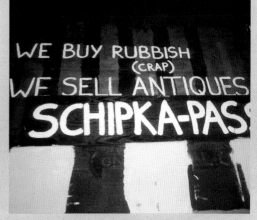

WE BUY RUBBISH
(CRAP)
WE SELL ANTIQUES
SCHIPKA-PASS

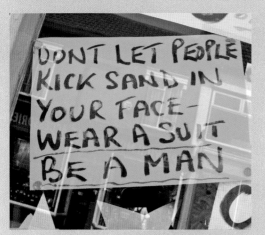

DONT LET PEOPLE
KICK SAND IN
YOUR FACE –
WEAR A SUIT
BE A MAN

FOR SALE 8/7/6
Woven Willow Coffin
Sof 5'9", Medium build – ish.
£100
make bookcase/storage until
needed ?!

Beautiful home!

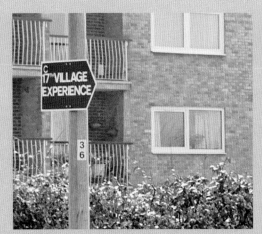

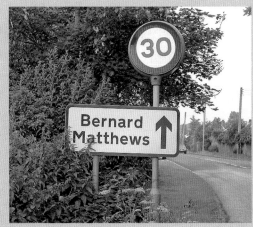

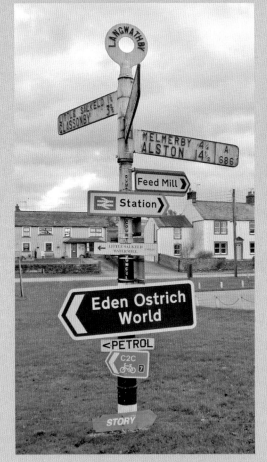

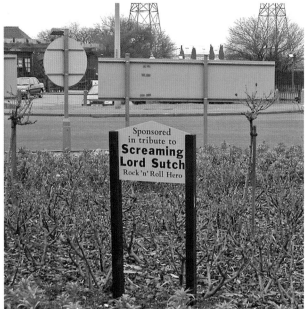

THIS STONE HAS BEEN ERECTED
FOR THE COMMUNITY BY
TREVERBYN PARISH COUNCIL
TO CELEBRATE THE MILLENNIUM.
JANUARY 1ST 2000

Sponsored
in tribute to
**Screaming
Lord Sutch**
Rock 'n' Roll Hero

What's great about Britain?

It's old,
interesting
and strange

What's not so great?

Excessive
political
correctness

Welcome to Britain

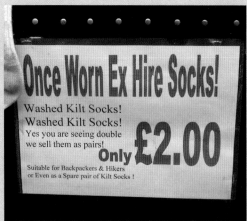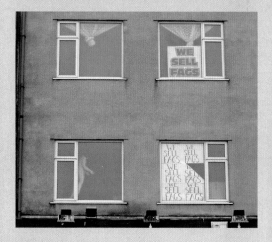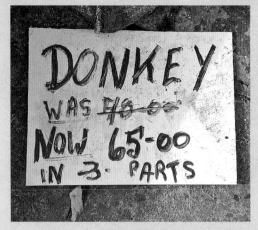

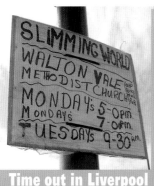

SLIMMING WORLD
WALTON VALE
METHODIST CHURCH
MONDAYS 5-0 p.m.
MONDAYS 7-0 p.m.
TUESDAYS 9-30 a.m.

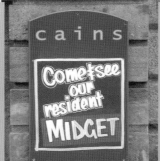

cains

Come & see our resident MIDGET

Millennium
BOOSTER BURNER BED
£1
6 MINS

Time out in Liverpool

LET FATE GUIDE YOU

ARBAAZ
50 COURSE MEAL
£9.95
CHILDREN
£4.95

Especially cleaned/put/ done/fixed* for 'Capital' of Culture judges visit. Disgraceful!!!

*Delete where appropriate

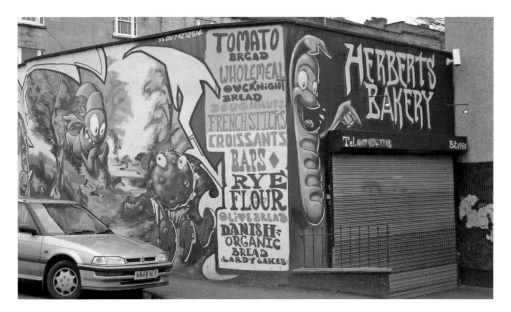

TOMATO BREAD
WHOLEMEAL OVERNIGHT BREAD
DOUGHNUTS
FRENCH STICKS
CROISSANTS
BAPS
RYE FLOUR
OLIVE BREAD
DANISH ORGANIC BREAD
LARDY CAKES

HERBERTS BAKERY

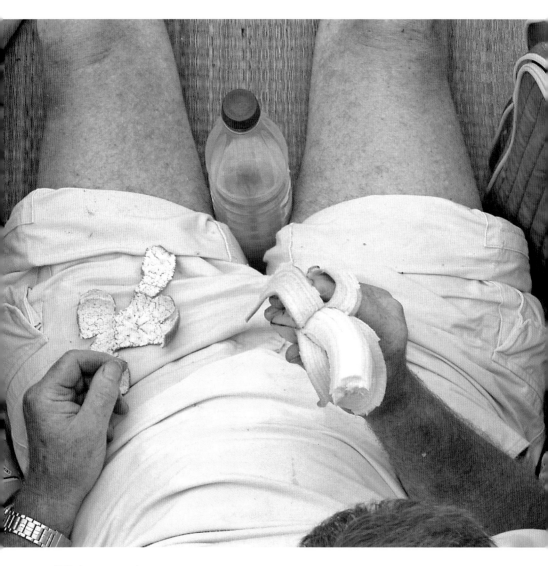

Picnics

As soon as the rain stops the
British rush outdoors to enjoy an
al fresco feast of sandwiches and
a banana. Their choice of location
or picnic partners can sometimes
seem puzzling.

What do you think of as 'typically British'?

Moaning and roadside picnics

Fish and chips in a bus shelter

Barbecues in the rain

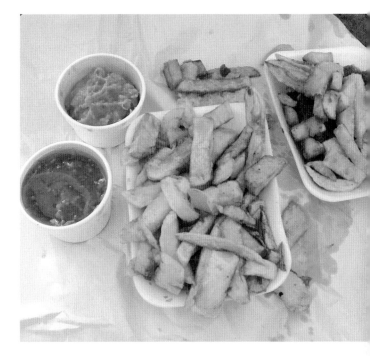

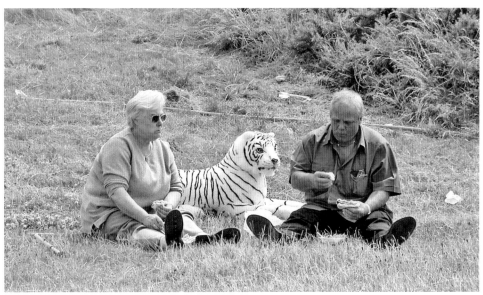

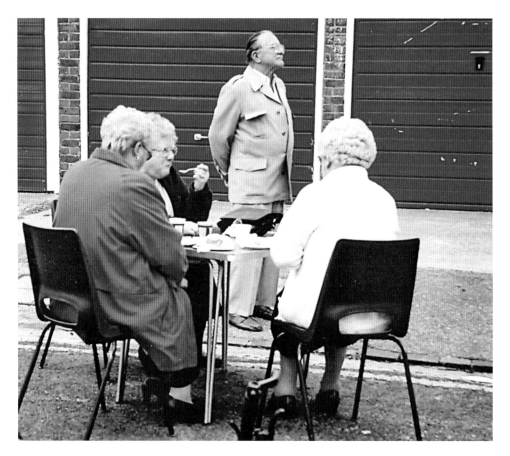

Welcome to Britain

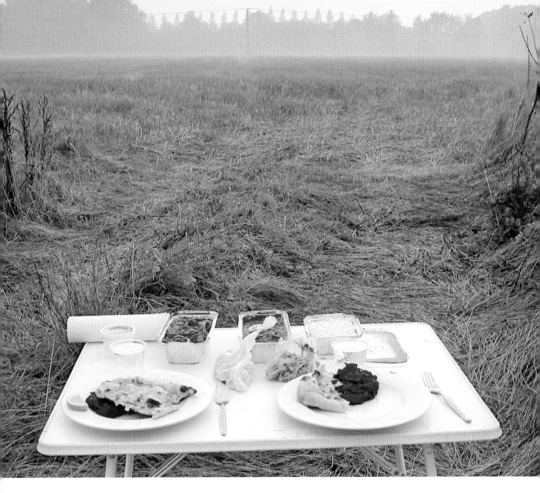

What's great about Britain?

Cornish pasties

What's not so great?

The amount of litter on the floor

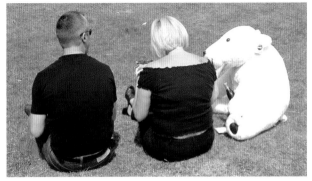

Welcome to Britain

The most important factor when planning a day out in Britain is to make sure that you are never more than five minutes away from a public convenience. Finding one that is open is especially rewarding.

(In)conveniences

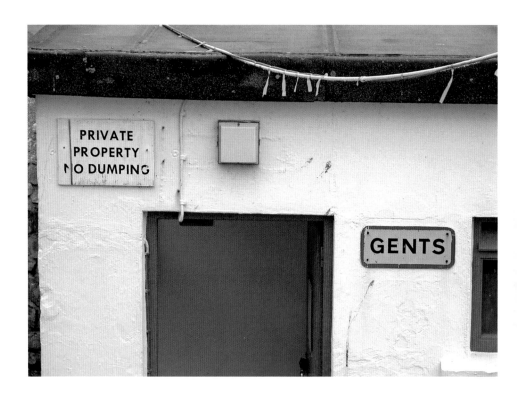

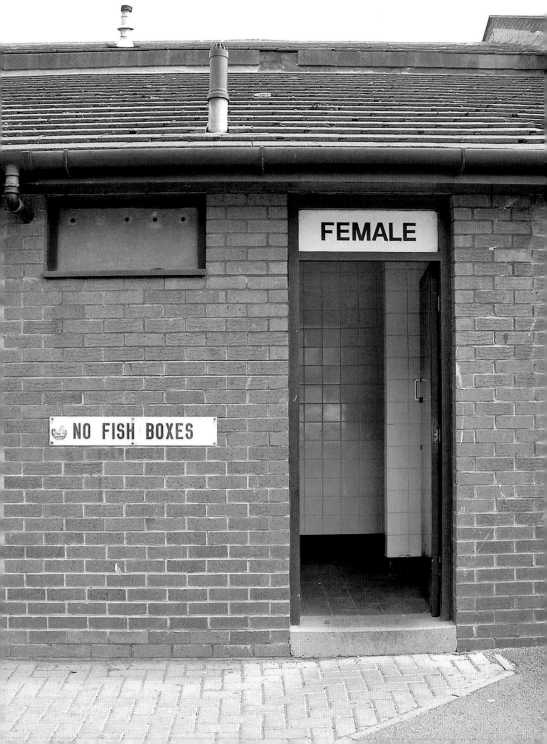

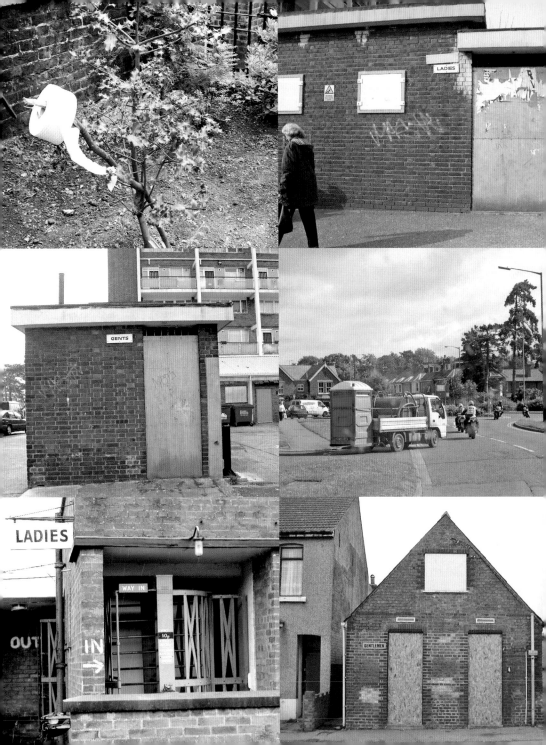

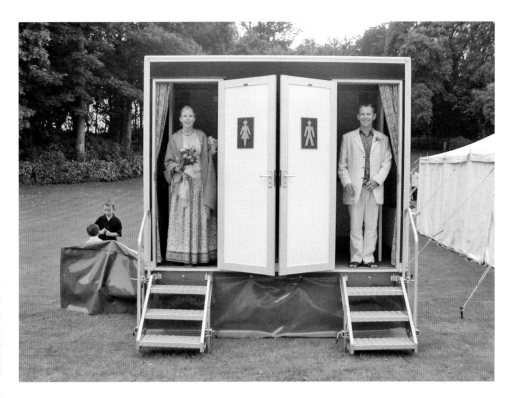

What's your personal motto?

You've already trodden in it

Laugh and the whole world will laugh at you

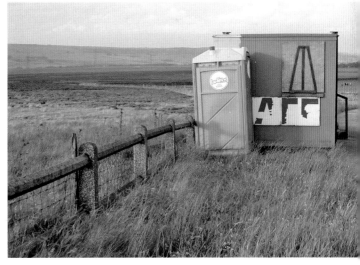

Welcome to Britain

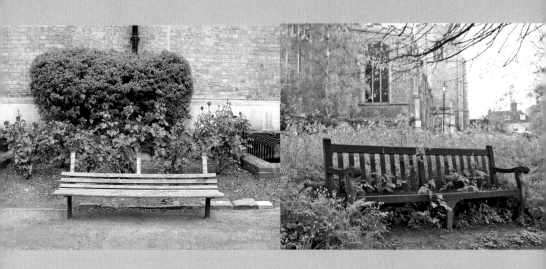

Benches

There is nothing like a nice little sit down in the fresh air to watch the world go by – only sometimes there is precious little to sit on.

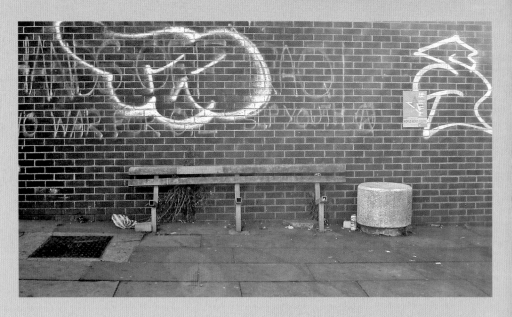

Welcome to Britain

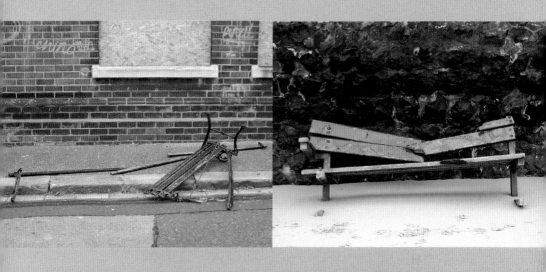

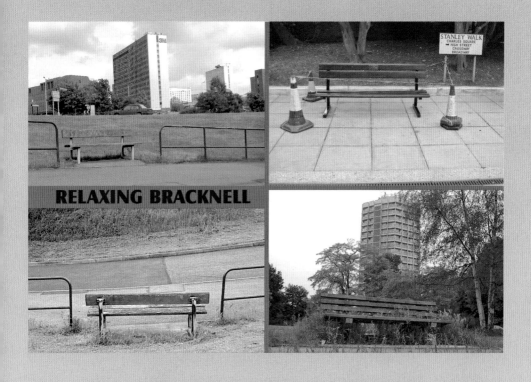

RELAXING BRACKNELL

What do you think of as 'typically British'?

A good fry-up after a hangover

What's your personal motto?

Let me eat cake

Never whistle with a mouthful of custard

Food

We like good plain food in Britain – nothing fancy. And we'll have chips with that, followed by some traditional handmade fudge. Except after the pub, when we'll have Chicken Vindaloo.

Welcome to Britain

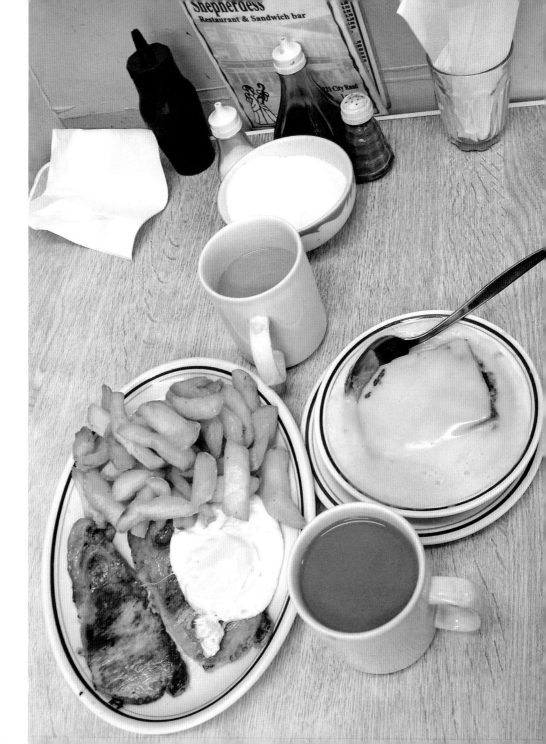

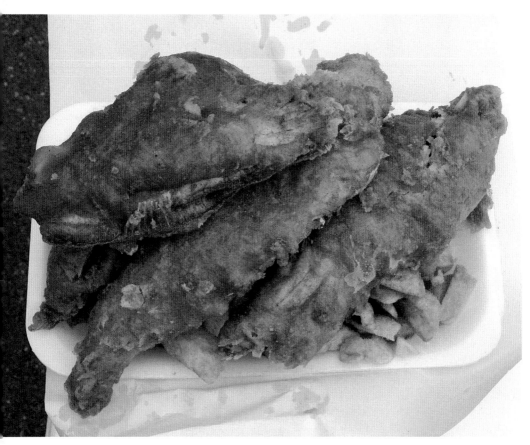

What's great about Britain?

Chips

What do you think of as 'typically British'?

Polite eating

Welcome to Britain

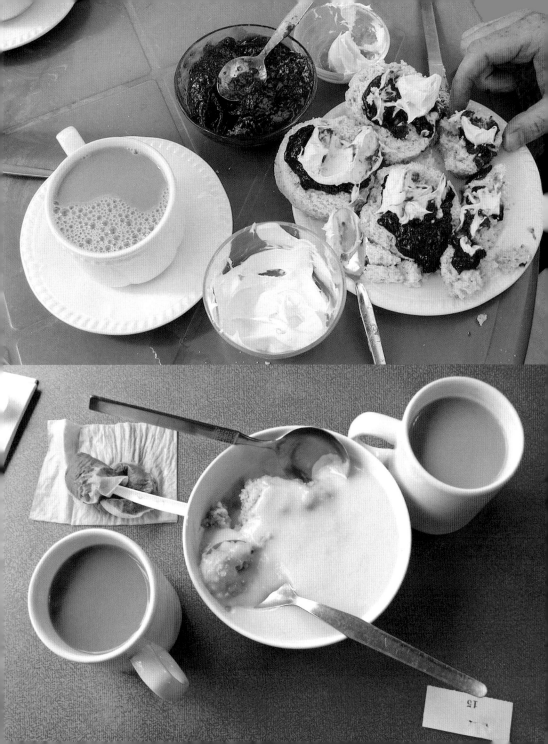

Looking good

With a bijou salon on every corner, there's no excuse for not looking gorgeous.

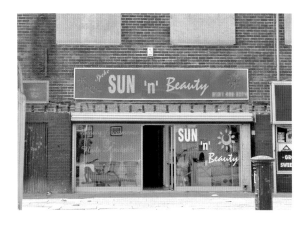

What is your personal motto?

Get slim to a size 10

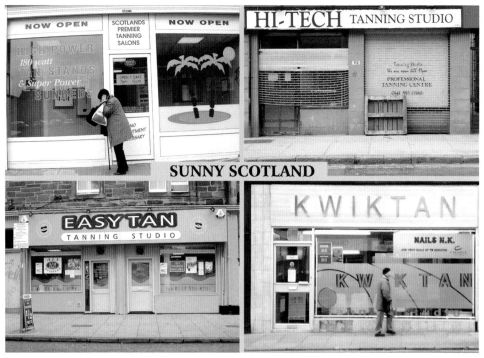

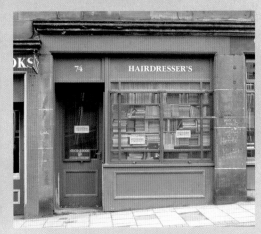

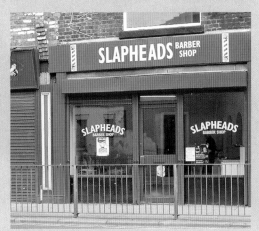

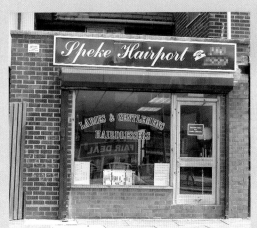

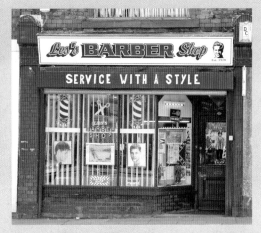

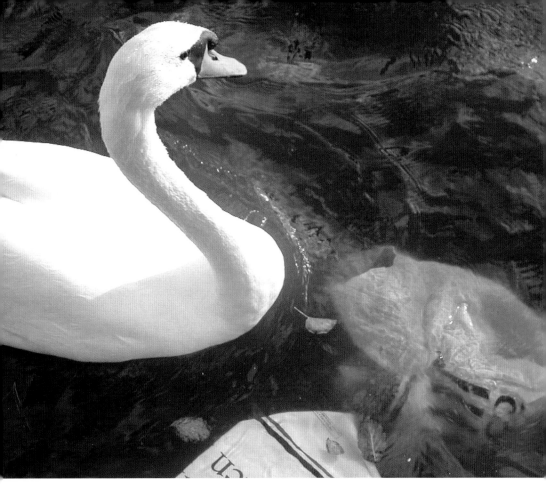

Water

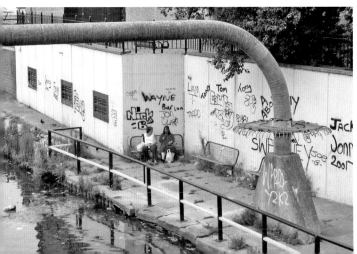

We're surrounded by water, plenty more falls on us and we love a lake, canal or river. It's just a pity we don't always look after them that well.

Welcome to Britain

RIVER THAMES

Welcome to Britain

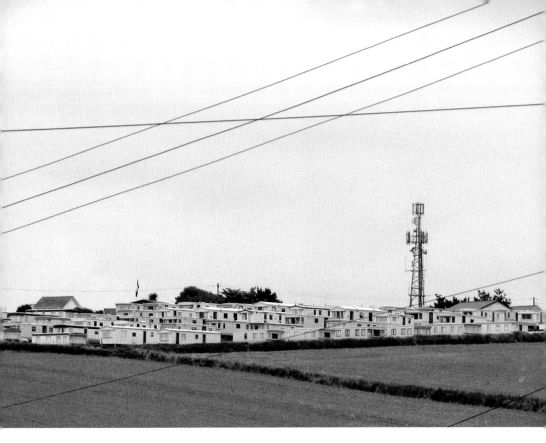

Countryside

The bits between urban areas that city people go to for a run out in the car. It can smell rather pungent, according to townies. Interestingly, people all over Britain – not just in the country – tell us that the residents of nearby neighbourhoods are 'all inbred over there'.

Welcome to Britain

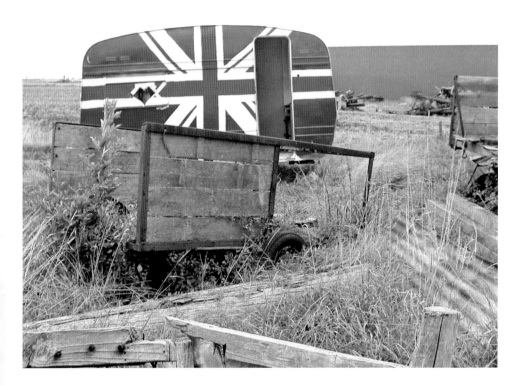

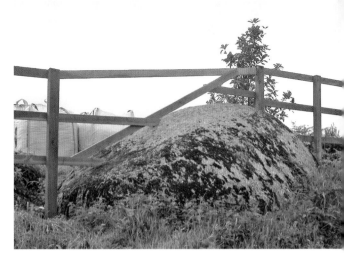

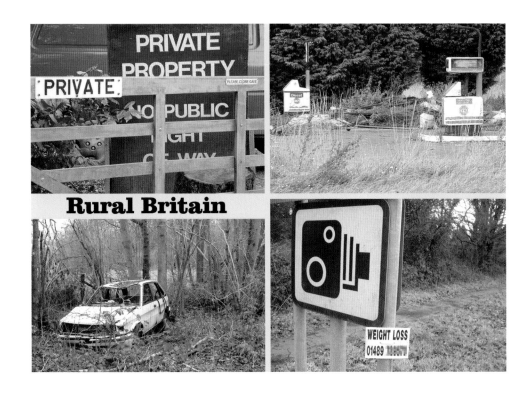

Rural Britain

WEIGHT LOSS
01489

PEOVER SUPERIOR PARISH COUNCIL
NOTICE BOARD

What's great about Britain?

The green parts

Welcome to Britain

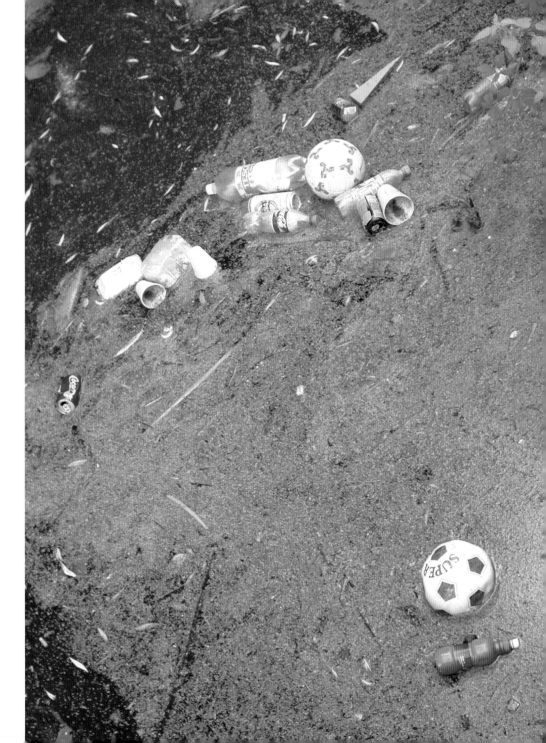

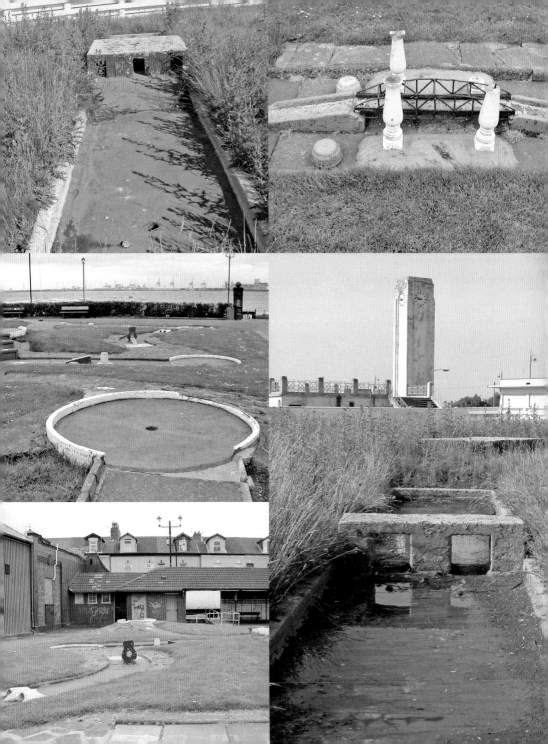

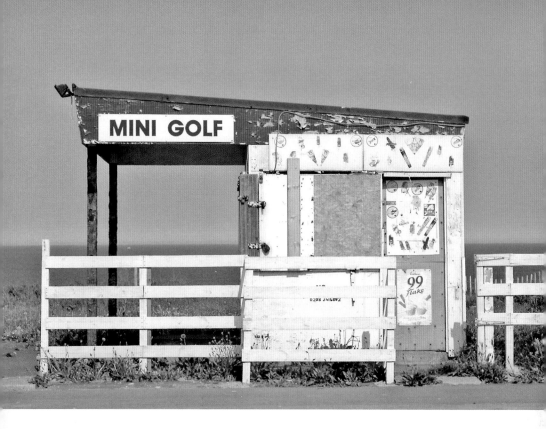

Mini-fun

Crazy Golf was once a popular pastime enjoyed by many a holidaymaker. What happened? Where did it all go wrong? And why was it so appealing in the first place?

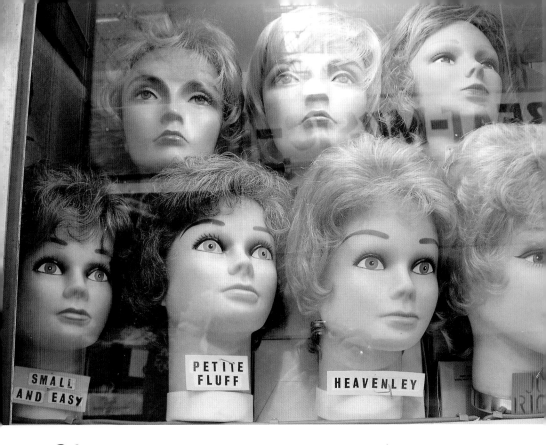

SMALL
AND EASY

PETITE
FLUFF

HEAVENLEY

Shop displays

In Britain, we are spoilt for choice when it comes to shopping. From pigs' heads to belly bands, a bewildering array of goods is available on every high street. Lovingly-created displays of items may further enhance the shopping experience.

Welcome to Britain

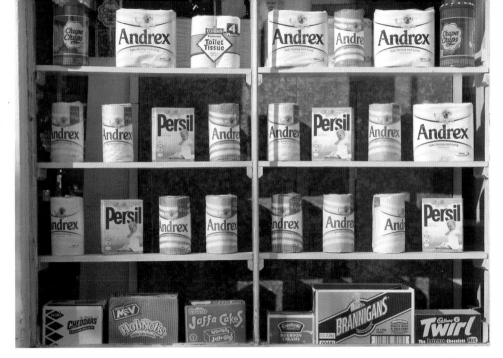

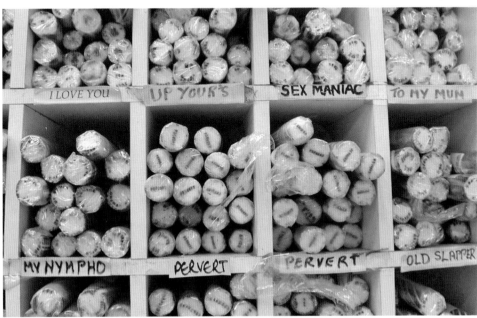

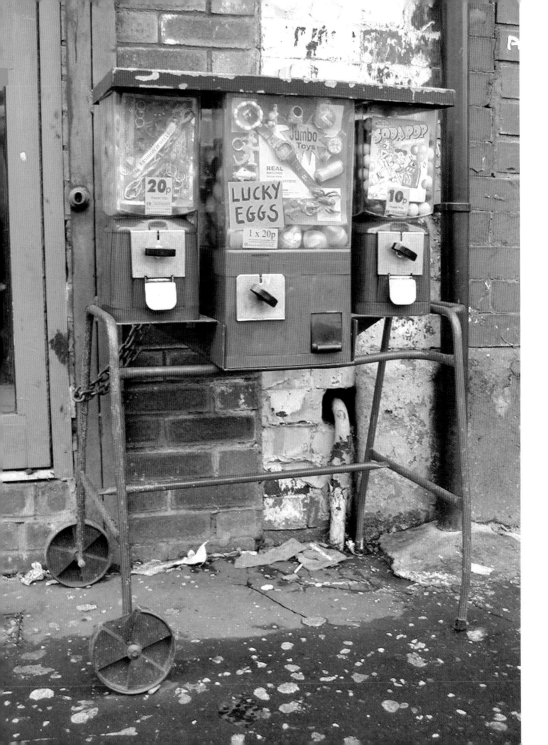

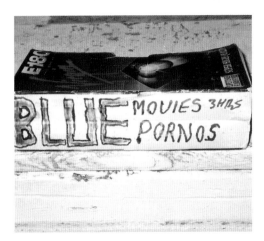

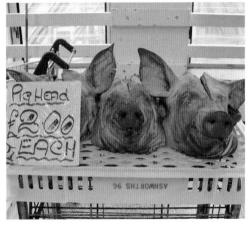

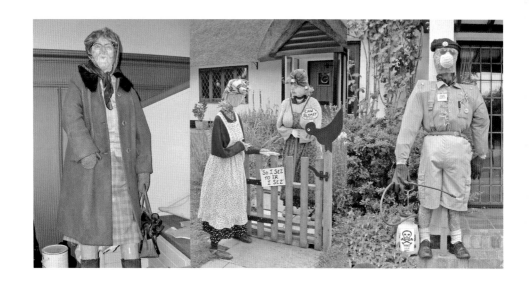

Public art

Little prompting is needed for the British public to get creative in the great outdoors, especially when it involves dressing up or stuffing things.

What do you think of as 'typically British'?

Freedom to be eccentric in a conformist kind of way

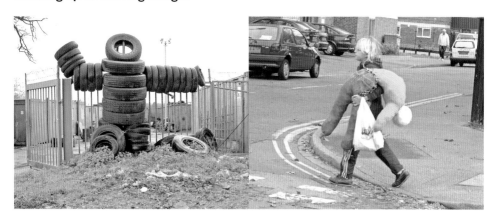

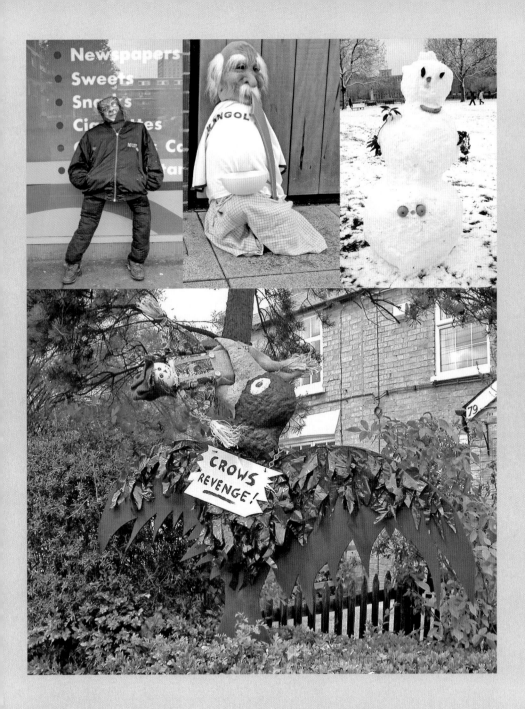

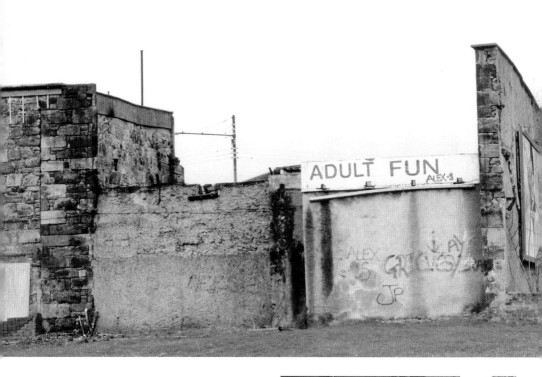

Smut

A play on words here, a missing letter there, an unfortunate pose. Nudge nudge wink wink – there's always an excuse for a bit of innuendo in Carry On Britain. Make mine a large one.

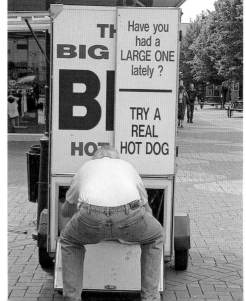

42% of people are looking for love

What's great about Britain?
Not sure at the moment

What's not so great?
Uptightness

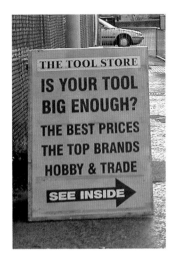

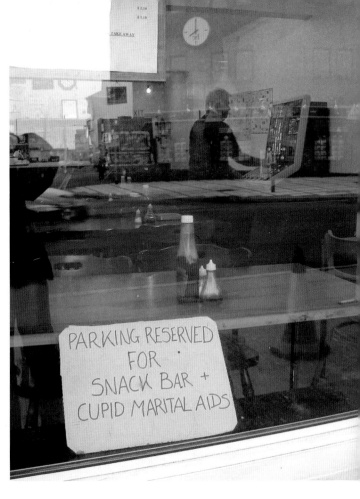

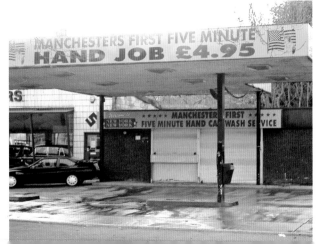

Welcome to Britain

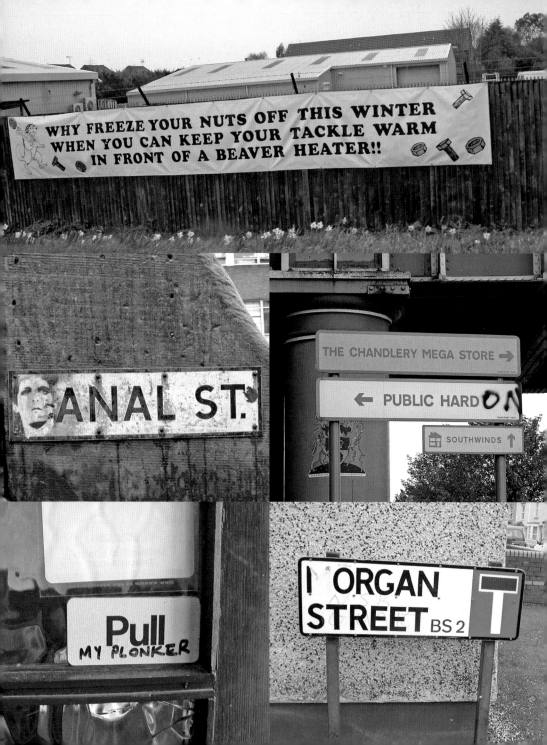

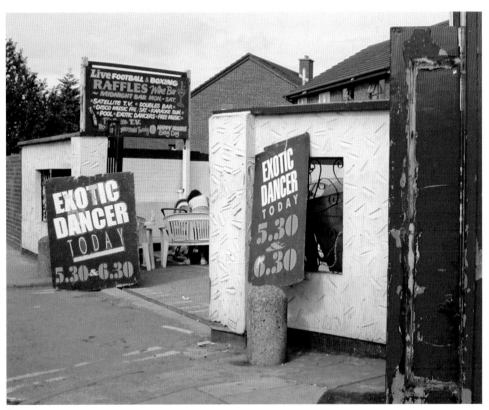

What's your personal motto?

Sex and shopping come first

Welcome to Britain

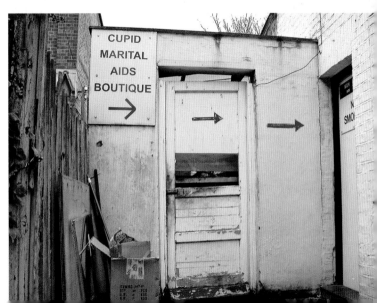

Mis ing lett rs

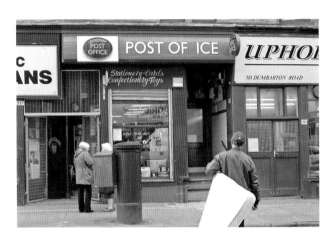

Sometimes less is more.

I was nearly killed by an 'S' from a sign falling on me

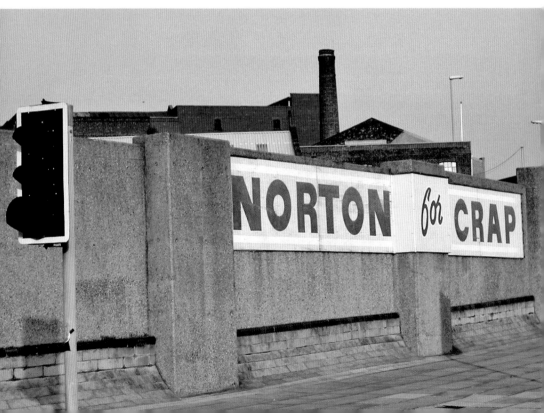

UTITS TO LET
S ITABLE FOR
VARIOUS
TRA ES
TEL

No DRINK
No POOL

CARLING

ve
OTBALL
CH IT HERE!

NO FOLK ARMS

£1·50

SENIOR CITIZEN
+ CHIPS
£2·70

SHITY SIJN
MEN I N ELMO IOI
FACT PIE OV
VERV POND BIULD N
C R SE RIE TOT
POO T R SO
ERS NS

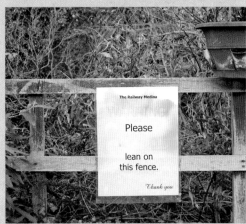

The Railway Medina

Please

lean on
this fence.

Thank you

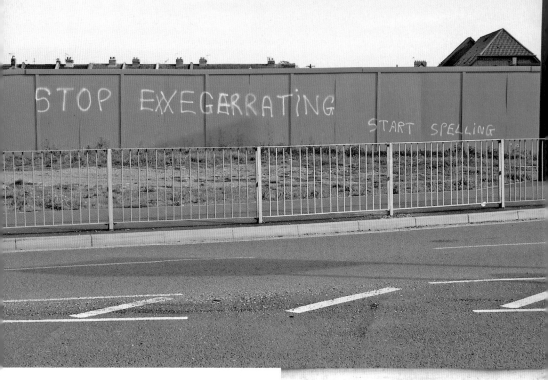

STOP EXEGARRATING

START SPELLING

Graffiti

**Need to make a public statement?
All you need is a big marker pen,
a can of spray paint or just a dirty
van and a finger.**

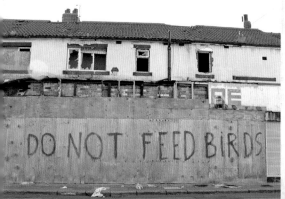

DO NOT FEED BIRDS

MAXINE IS
UNREALISTIC

MAXINE
loVES
Lynchie
forever Together
never TO pIARt
Cause maxine And
Lynchie love Eachothe
wAE All of there heat
PARTNERS
FOR
LIFE

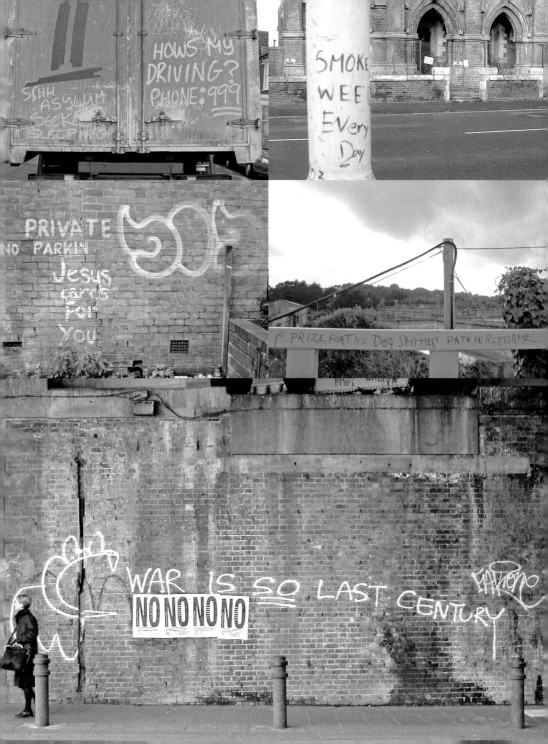

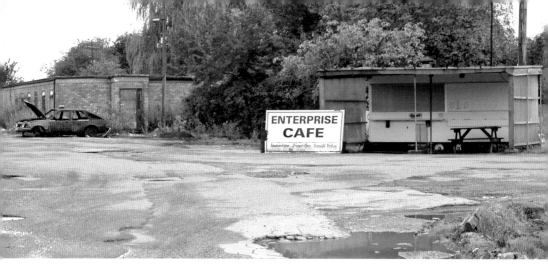

Cafes

A proper mug of tea and an all-day breakfast followed by spotted dick and custard, eaten at a Formica table while sat on a plastic chair. Where else could you be?

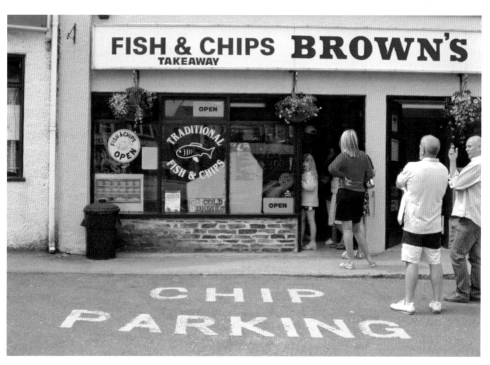

What's your personal motto?

Don't eat anything bigger than your head

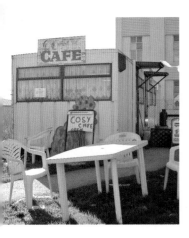

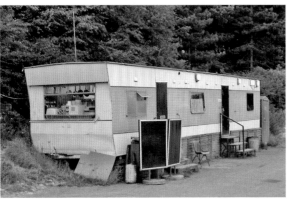

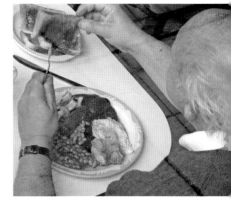

Support your local greasy spoon; it may not be there much longer.

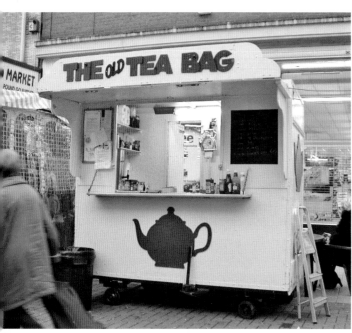

What do you think of as 'typically British'?

Union Jacks, bulldogs, pie and mash

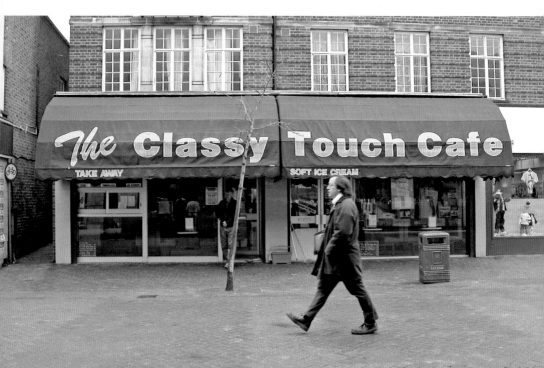

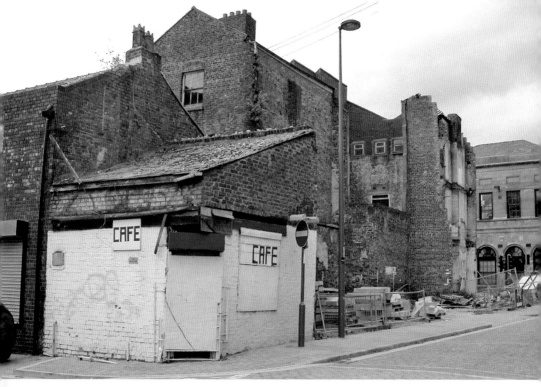

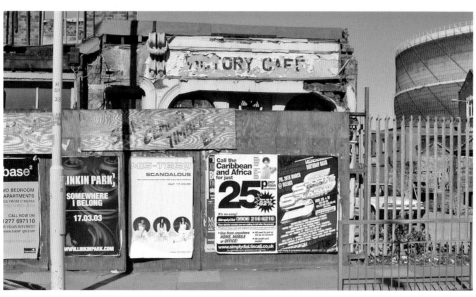

Welcome to Britain

People of Britain

Freedom of expression is highly valued in Britain, even if it means shopping in a crash helmet, brandishing a homemade placard or mowing the pavement. It's a very special place indeed.

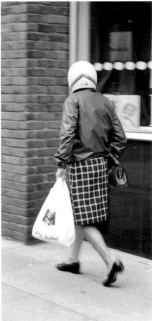

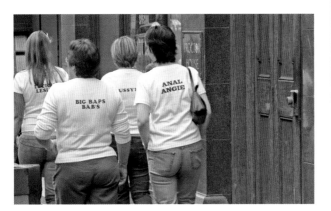

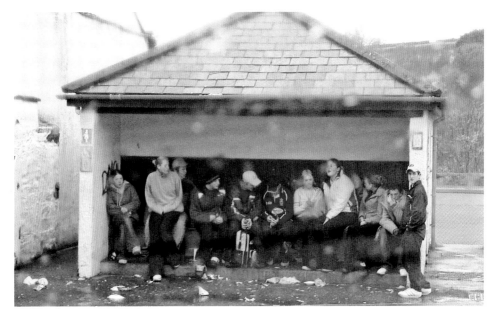

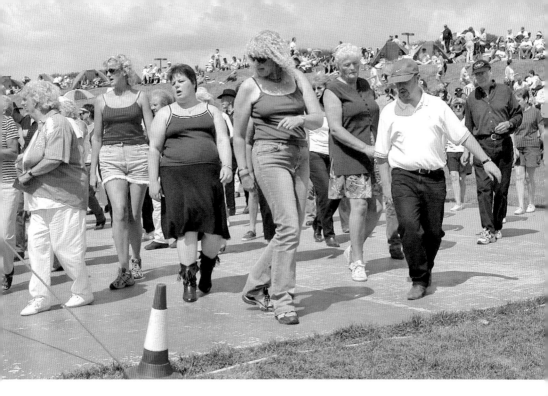

The British have often shown a keen interest in all things Country and Western, and line dancing is particularly popular. Positioned in orderly rows, dancers in Southsea reveal their Achy Breaky Hearts; while other enthusiasts form a breakaway faction of their own.

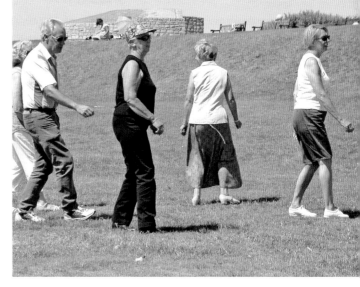

What's great about Britain?
We can laugh at ourselves

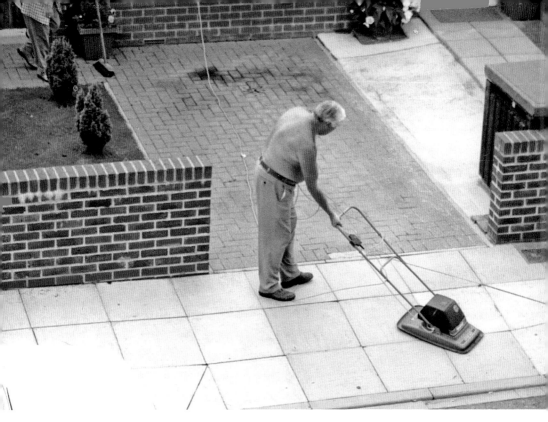

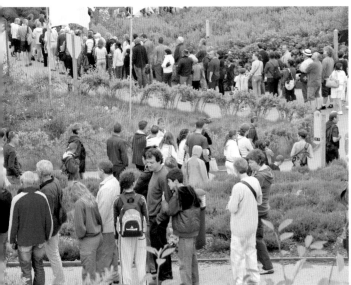

What's great about Britain?

Our ability to queue

We know how to say 'please' and 'thank you'

What's not so great?

People who don't have any manners

Welcome to Britain

Stratford - upon - Avon

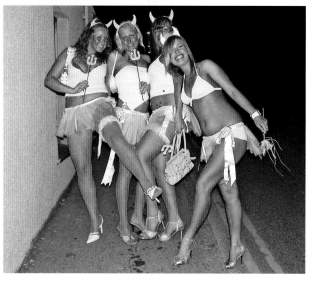

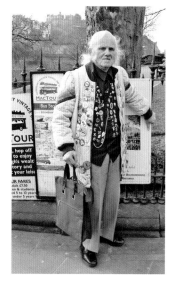

Welcome to Britain

What's your personal motto?

TV is no substitute for real life

Those who say it cannot be done should not get in the way of those doing it

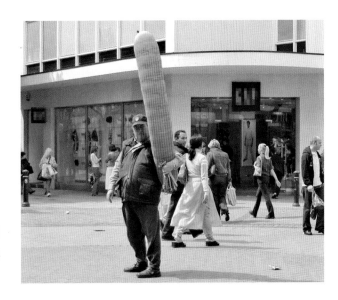

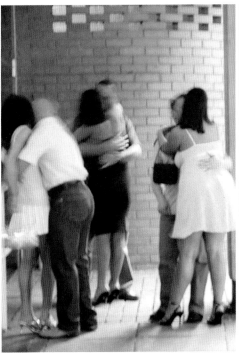

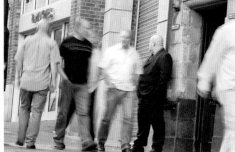

Newcastle Nightlife

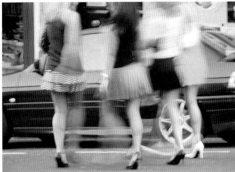

Location Guide

(Page by page, from left to right, top to bottom.) **Dedication page:** The Caravan Gallery postcard – Ipswich. **Title page:** a cafe near you; Southsea; Portsea, Portsmouth. **Contents page:** Mottisfont Abbey, Hampshire (National Trust); Newcastle; Alresford. **Introduction:** The Caravan Gallery at the Eden Project, Cornwall; Liverpool; Bracknell; Liverpool; Liverpool. **Conifers (dead):** Cambridge; Isle of Wight; Notting Hill, London; Bracknell; Christchurch; anywhere; Sandhurst. **Conifers (thriving):** West Howe, Bournemouth; Jesus College, Cambridge; Corsham. **Little trains:** Fratton, Portsmouth; Fratton; West Howe, Bournemouth; Bracknell. **Markets:** Fratton, Portsmouth; Newcastle and Gateshead; Lizard Peninsula, Cornwall; London; Fratton; Winchester; Glasgow. **Homes:** Beeston, Leeds; Liverpool; Point Royal, Bracknell; Slough; The Gorbals, Glasgow; Leeds; Cumbernauld; Chalvey, Slough; Newlyn, Cornwall; The Gorbals, Liverpool; Mousehole, Cornwall; Cumbernauld; Alloa; Hartlepool; Lavenham, Suffolk; Liverpool. **Dogs:** Liverpool; Sheffield; Southsea; Edinburgh; Southsea; Portsmouth; Edinburgh; Christchurch; Clifton, Bristol. **Birds:** Tintagel; St Ives; Newquay; York; Land's End. **Pigeon people:** Fratton, Portsmouth; Leeds; Shirley, Southampton; London; Newcastle; Portsmouth. **Bins:** Coventry; Brandon; Southsea; Skegness; Huntingdon; Newquay; Perranporth; Mevagissey; Bury St Edmunds; The Caravan Gallery postcard – Liverpool; Edinburgh. **Street entertainment:** Manchester; Liverpool; Brighton; Hunstanton. **Ex-garages:** Baldock; Gorton, Manchester; Liverpool; Gosport; Cornwall; Holbeck, Leeds; Speke, Liverpool; Land's End; Unknown; on the A505; York. **Gardens:** Somerstown, Portsmouth; Winchester Hat Fair; Ipswich; Southsea; The Caravan Gallery postcard – various; Portsmouth; Harlesden, London; Alton; Newlyn, Cornwall; Hackney, London; probably Sussex; Tottenham, London; site of Liverpool Garden Festival; Skegness; Cornwall; Paulsgrove, Portsmouth. **Closed:** Somerstown, Portsmouth; London; Portsmouth; Walthamstow, London; Paulsgrove, Portsmouth; Southsea; the Tricorn, Portsmouth; Brighton; the Tricorn, Portsmouth. **Concrete:** Slough Bus Station; Liverpool; The Caravan Gallery postcard – Portsmouth; the Tricorn, Portsmouth; Gateshead; Norwich; Leeds; Bracknell. **Today's news:** all over Britain. **Amusements:** Seaton Carew, Hartlepool; Pagham, West Sussex; Blackpool; Cornwall; Southport; Land's End; Pagham; Whitley Bay; London; Seaton Carew; The Caravan Gallery postcard – various (all taken on August Bank Holiday); Skegness; Southport. **Cinemas-cum-churches:** Kirkdale, Liverpool; Fratton, Portsmouth; Willesden, London; Cumbria; Lostwithiel; Norwich; Rowlands Castle, Hampshire; Gorton, Manchester; Gorton. **Seaside:** Cornwall; Perranporth; Skegness; Hove Actually; Land's End; Southport; Felixstowe; Skegness; Felixstowe; Perranporth. **Getting about:** Skegness; Horden, Co. Durham; Liverpool; Cambridge; Bristol; Fowey; Birmingham; Slough. **Ex-transport:** Portsmouth; Brighton; Brighton; Gorton, Manchester; Portsmouth; Axbridge; Portsmouth; near Salisbury. **Relaxing:** Hunstanton; Cornwall; Skegness; Perranporth; Leith Hill, Surrey; Brighton; Hove; Cornwall; The Caravan Gallery postcard – Southsea; Padstow; Hyde Park, London. **Public houses:** Walton, Liverpool; Blackpool; Cambridge; North Shields; Bristol; Glasgow; Kirkby, Liverpool. **Chicken:** The Caravan Gallery postcard – various; Newport, Isle of Wight; Everywhere. **Dereliction:** Chatteris; Liverpool; Benwell, Newcastle; Gateshead; Everton, Liverpool; Birkenhead; Liverpool. **Regeneration:** Hartlepool; London; Manchester; Manchester. **Ornamentation:** Newcastle; West Sussex; Cornwall; London; Cambridge; Emsworth; Cornwall. **Shops:** Blackpool; Hackney, London; Hackney; Blackpool; Partick, Glasgow; Southwark, London; Sheerness; Gosport; Liverpool; Blackpool; Blackpool; Islington, London; Oxford. **Fashion:** Southsea; London; Leeds; The Caravan Gallery postcard – Liverpool; Wrexham; Salisbury. **Side by side:** Somerstown, Portsmouth; The Gorbals, Glasgow; Bristol; Liverpool; South Gare, near Redcar; Newcastle; Liverpool; Bracknell. **Showgrounds:** The Caravan Gallery Postcard – various; Portsmouth; Netley, Southampton; Netley. **Signs:** Lizard Peninsula, Cornwall; Alloa; Downham Market; Southsea; Holmfirth; Mevagissey; Cornwall; Glasgow; Ipswich; Totnes; Gosport; Norfolk; Langwathby, Cumbria; Hackney, London; Alton; Chester ; Bugle, Cornwall; Isle of Sheppey; York; London; Edinburgh; Glasgow; Blackpool; Cornwall; Netley; The Caravan Gallery postcard – Liverpool; Montpelier, Bristol. **Picnics:** Perranporth; anywhere; New Brighton; Somerstown, Portsmouth; Levenshulme, Manchester; the pavement; a field near Long Stratton, Norfolk; New Brighton. **(In)conveniences:** Somewhere near London; Mousehole, Cornwall; North Shields; near Waterloo, London; Britwell, Slough; Britwell; Stratford-upon-Avon; somewhere near York; Halfway, Isle of Sheppey; Padstow (a marriage of convenience); Cumbria. **Benches:** near Waterloo, London; Bury St Edmunds; Brighton; Portsmouth; Blackpool; The Caravan Gallery postcard – Bracknell. **Food:** Alresford; Newcastle; Glasgow; Tintagel; Hackney, London; Newlyn, Cornwall; Portsmouth; the West Country; Clifton, Bristol. **Looking good:** Speke, Liverpool; The Caravan Gallery Postcard – Scotland; Perranporth; Chatteris; Edinburgh; Liverpool; Speke; Liverpool. **Water:** Southsea; Bootle; Liverpool; The Caravan Gallery postcard – London. **Countryside:** Cornwall; The Fens; March; The Fens; Luxulyan, Cornwall; The Caravan Gallery postcard – various; Cheshire; Huntingdon. **Mini-fun:** Seaton Carew, Hartlepool; New Brighton; New Brighton; Seaton Carew; New Brighton; Whitley Bay; Sheerness, Isle of Sheppey. **Shop displays:** Leeds; Slough; Cambridge; Brighton; Rusholme, Manchester; Partick, Glasgow; Bury St Edmunds; Glossop; Walthamstow, London; Glasgow; Liverpool. **Public art:** Alloa; Abbotsley, Cambridgeshire; Abbotsley; Slough; Somerstown, Portsmouth; Somerstown, Portsmouth; London (by the London Eye); Abbotsley. **Smut:** Glasgow; Bracknell; Slough; Christchurch; Manchester; Chichester; Manchester; Bursledon, Hampshire; Newlyn, Cornwall; Bristol; Walton, Liverpool; Slough. **Missing letters:** Partick, Glasgow; Liverpool; near Holmfirth; Slough; Marple Bridge, Cheshire; Newport, Isle of Wight; Alton; Ramsbottom, Lancashire. **Graffiti:** The Pompey Centre, Portsmouth; Leeds; Edinburgh; Portsmouth; Gorton, Manchester; Norwich; Parr, Cornwall; Hackney, London. **Cafes:** The Fens; Perranporth; Hackney, London (Cosy Cafe); Rhyl; Lincolnshire; Liverpool; Walthamstow, London; Slough; Liverpool; Hackney. **People of Britain:** Newcastle ; Portsmouth (crash helmet); Helston; Southsea; Southsea; Portsmouth; the Eden Project, Cornwall; Edinburgh; London; Penzance; The Caravan Gallery postcard – Stratford-upon-Avon; Newquay; Edinburgh; Liverpool; The Caravan Gallery postcard – Newcastle.

All locations given are as accurate as possible. If we've missed anything, please contact us via our website: www.thecaravangallery.co.uk